LAUNCHING YOUR ART CAREER:
A Practical Guide for Artists

By Alix Sloan

Although the author has made every effort to ensure that the information in this book was correct at press time, the author does not assume and hereby disclaims any liability to any party for any loss, damage, or disruption caused by errors or omissions, whether such errors or omissions result from negligence, accident, or any other cause.

Passion Project Publishing

Cover Design: Shane Eichacker

Editor: Amy Eyrie

Copyright © 2015, 2017 Alix Sloan

All rights reserved.

ISBN: 1514628449
ISBN-13: 978-1514628447

For Katherine Chapin.
The only thing she appreciated more than a
compelling work of art, was the artist who created it.

Table of Contents

Part One - Getting Started ... 6
 Chapter One - What To Expect From This Book ... 8
 Chapter Two - Some Basic Terms ... 10

Part Two - Preparing For Success ... 14
 Chapter Three - Setting Goals ... 16
 Chapter Four - Community & Networking ... 19
 Chapter Five - Support Materials ... 22

Part Three - Your Studio ... 30
 Chapter Six - Creating a Productive Space ... 32
 Chapter Seven - Task & Time Management ... 35
 Chapter Eight - Studio Visits ... 39

Part Four - Exhibiting Your Work ... 42
 Chapter Nine - Finding & Approaching Galleries ... 44
 Chapter Ten - Curated Shows & Competitions ... 50
 Chapter Eleven - Other People & Places ... 55
 Chapter Twelve - Creating Your Own Opportunities ... 58
 Chapter Thirteen - Working with Galleries ... 65
 Chapter Fourteen - Art World Etiquette ... 73

Part Five - Selling & Pricing Your Work ... 76
 Chapter Fifteen - Types of Sales ... 78
 Chapter Sixteen - Pricing Your Work ... 84

Part Six - More About Money ... 90
 Chapter Seventeen - Other Ways to Make Money ... 92
 Chapter Eighteen - Budgeting, Taxes & Trades ... 100

Part Seven - What Do Other People Say? ... 104
 Chapter Nineteen - Advice from Artists & Dealers ... 106

Part Eight - Reminders, Requests & Resources ... 152
 Chapter Twenty - Wrapping Up ... 154
 Chapter Twenty-One - Online Resource List ... 156

Part One: *Getting Started*

Chapter One
What To Expect From This Book

After two decades in the art world as a curator, consultant, private dealer and gallerist, I've seen hundreds of careers skyrocket, plummet, stall, ebb and flow. I can tell you with absolute confidence that there is no secret handshake, no magical pixie dust, no certified road map to success. I won't reveal any of those shortcuts here because they don't exist. But if you are making art you believe in, and willing to work hard and stick with it, this guide does contain advice and tools that will help you:

- Understand and navigate the art world.
- Find and create opportunities.
- Exhibit and sell your work.
- Be prepared and professional.
- Build and advance your career.

One of the challenges I find many artists face is accepting that the art world is a business. I know that can be a depressing thought. We don't have to dwell on it. But by choosing to exhibit and sell your work you are agreeing to participate in a system that is, at the end of the day, an industry. You are your own business. If that is something you struggle with, consider this - How many people get the chance to do what they love and get paid for it? Far too few. You have an opportunity to do

what you love, share it with others, and hopefully make a living. That's something to be excited about, not put off by.

This book is broken down into eight sections. After this intro, you'll find a list of basic terms. Give those a glance, just to make sure you're clear on the terminology I'll be using.

Sections two through six take you from more general concepts like setting goals and networking, to more practical information about creating effective support materials and running your studio, to information about tackling the challenges of getting your work out there, surviving and thriving. You'll get the most out of those sections if you read them in order, as they start with laying a foundation and then build from there.

Because none of us has all of the answers, and everyone has a different experience, I reached out to some of my colleagues - working artists, many of whom are well-respected teachers, and also art dealers who work with emerging to mid-career artists - and asked them to each share one piece of advice with you. You'll find their varied and inspiring contributions in section seven.

In the final section, I wrap things up with a few reminders, a few requests and a list of additional resources you can access online.

At the very end of this guide you'll find more information about me if you're curious. The short version is, I've been honored, inspired and educated by working with hundreds of artists throughout my career. I know that everyone who reads this book will be approaching building their career from a different place. But my hope is that by sharing what I've observed and learned, I can provide you with the information, motivation and inspiration you need to start, restart or continue your life as a working artist, with the best possible experience and results.

Chapter Two
Some Basic Terms

As you interact with larger and larger galleries, there will be more and more people involved in its day-to-day operations. For the purposes of this book, here's a short list of people and terms you're likely to run into right away:

- Gallerist - A gallerist is the person who owns or runs a commercial gallery. It's common at a small to medium-sized gallery for the gallerist or owner to also be the gallery director. Often these terms are used interchangeably.
- Gallery Director - This person makes decisions about exhibitions, looks for new artists, engages with the art world, collectors, and makes sales. The gallery director will most likely be your primary contact at a gallery.
- Gallery Manager - A gallery manager usually runs the more practical day-to-day aspects of the gallery, but is not involved in curating shows or making decisions about who exhibits at the gallery.
- Art Handler - This person is employed full time or freelance by a gallery or art handling company. Art handlers carefully and professionally pack, install, and transport your art.
- Curator - This is the person who comes up with the idea for a

show and puts it together. In a traditional gallery setting, this may be the gallerist or director. Sometimes a gallery will bring in an outside curator to organize a special exhibition. Nonprofit spaces and arts organizations use outside curators regularly.

- Juror - In the case of an open call or juried show, this is the person who looks through submissions and picks the art for a show. This person is also sometimes the curator.
- Consultant - This is a very loose term for someone who gets paid in some way to have an opinion about art. Many private and corporate collectors employ consultants to help them select and purchase art.
- Art Dealer - This is probably the most general term for someone who sells art. Gallerists are art dealers. Consultants who sell work are art dealers. If an interior designer sells a client a piece of your art, they are acting as your art dealer in that moment. I use dealer and gallerist pretty interchangeably throughout the book, but mostly gallerist because it's the term I'm most accustomed to using.
- Commercial Gallery - By commercial gallery I mean a gallery that exhibits and sells artwork, not a nonprofit space. There is an extraordinarily broad range of galleries within this category. You can usually get a pretty good idea of the general vibe of a space by researching what they show, where they are, how they market and present the gallery and exhibitions, and general word of mouth.
- Nonprofit Galleries, Centers & Organizations - A nonprofit raises money from various sources including sales, fundraisers and donations. It then puts that money back into funding its programs. As with commercial galleries, you will come across a wide range of professionalism and cachet within this category.
- Art Fairs - An art fair, for the purposes of this book, is an organized event where galleries exhibit and sell art by the artists

with whom they work. There are many different types and levels of art fairs. They are held in cities and countries all over the world. Galleries apply, and pay, to participate in these curated fairs.
- Community Art Fairs & Festivals - These are organized events where artists or artists' representatives can sell art. They are often held in conjunction with other local events such as a wine, food or music festival.

Part Two: *Preparing For Success*

Chapter Three
Setting Goals

This section will help you lay the foundation for launching, relaunching or advancing your art career. I know there is a temptation to jump ahead and dive into the information about showing and selling your work. But I really believe that the steps in this section are just as important. Artists who make smart decisions based on their goals, maintain a healthy community and network, and take the time to create excellent support materials, are the most successful.

One of the questions I ask any artist I consider working with is, "What are your goals?" The response I get most frequently is, "I never really thought about it." If you're not sure what your goals are, now is a good time to think about it. Dedicating your life to your art is a brave, exciting, powerful choice. But no matter how talented you are; it's not going to be an easy journey. Why not tip the odds in your favor? Ask yourself what you really want. Then make decisions along the way with those goals in mind. There's no wrong answer to this question as long as it's honest. And it doesn't have to be your forever answer. Your right now answer will do. I've heard everything from "I want to make good work and support myself with my art" to "I want to inspire others and create community through my work" to "I want to make art and live in Europe" to "I want to see my art in a museum" to "I want to be

famous." I've heard it all.

By determining what your goals and desires are, you can be clear with yourself and others as you navigate the great big, amorphous art world. And then you can - and this is just as important - *keep those goals in mind every time you make a decision.* Ask yourself "Does this decision support my goals? And if not, why am I doing it?" By making consistent choices that support your goals, you can avoid wasting time and energy on things that don't matter to you.

So before you proceed any further, take a minute to really think about what you care about and how you imagine your life and career. Don't worry about judgments or get hung up on eloquence. No one else needs to hear it. Just make sure you're honest about what you want and your vision is in alignment with your values. What are your goals for the immediate future? Five years from now? Ten years from now?

For the immediate future (let's say the next twelve months), consider this as a starting point: "To make good work and share it." It's vague but it's also simple, direct and allows a lot of room for exploration and success.

For your longer term goals, get more specific. I'll say this again and again; the art world is vast and varied. If your singular goal is to make a living as an artist, that opens up a broader range of options for you to pursue. For instance, there are plenty of retail based commercial galleries in high traffic locations that mainly sell art to clients who walk in off the street. There is nothing wrong with that. And with the right relationship you can make a good living. But that kind of gallery is not a good fit for someone who is determined to participate in, and make an impact on, the contemporary dialogue. If making a mark on the art world is your goal, you should work towards showing with galleries that are more focused on trying to place work in influential collections.

It's OK if you just aren't sure about the long-term goal right now. If that's the case, just roll with "To make good work and share it," or

whatever your immediate goals are, for now. After a few months or a year, revisit the topic with more perspective. And whatever goals you set, don't forget to keep tabs on them. Throughout your career, once a year or whenever you hit a really big milestone, revisit and consider revising your goals. Cross off the goals you accomplished, and replace them with new aspirations.

Chapter Four
Community & Networking

The life of a studio artist can be lonely. But you are not alone. If you think globally, there are millions of artists just like you out there, making art to share with the world. Your artist friends, colleagues and acquaintances are your lifeline to sanity, perspective, encouragement, and opportunity. I promise you, dedicating even a small amount of your time and energy to supporting your community and building a network will enrich your experience and reap tremendous rewards.

Consider your *community* your "real friends." These are people you really know. Someone you might go to an opening with, ask to come by for a studio visit, or touch base with when you need a pep talk or advice. Your *network* consists of colleagues, casual online friends, people you run into at shows but don't know well. An artist recently said to me "I don't want to make friends with people just because I might get something out of it." That's not what I'm talking about here. I'm encouraging you to develop sincere, reciprocal relationships with other artists and art professionals that are enjoyable, productive, and enrich your life.

If you're fortunate enough to already have a community of artist friends, not just acquaintances but close friends, get a group together over coffee or drinks to talk about ways you can support each other.

Share your goals. Make a commitment to let each other know if you spot an interesting opportunity. Help each other out with feedback when asked. Plan a museum or gallery outing. I know one group of artists that meets monthly just to share progress and keep each other motivated. Being accountable to each other helps all of them accomplish more between meetings. Consider setting up your own regular get-together. You can even do it over email if need be. Most of us can spare a few moments or hours once a month to give and receive encouragement and feedback.

If you don't have a community, and even if you do, start looking for new ways to network and connect with other artists in real life. Attend openings whenever possible. You don't even have to talk to anyone at first. Everyone wants a good turnout at their show. Showing up, even for an artist you don't know, is a really nice thing to do. Just start getting out there. If there's an affordable class you are interested in, that's another great way to meet people. I'm not saying you have to pick up a bunch of new pals, but by opening yourself up to new people and experiences within the art world, you will be putting yourself in the path of inspiration, interaction and opportunity.

Then, of course, there's the internet. Look for artists whose work you find interesting, send them friend requests, "like" their pages and posts, follow them on Instagram, Twitter, whatever is popular at this particular moment. Many artists share information online about open calls for shows, resources for materials, grants and residencies. It's a great way to keep up on what's going on. And you should do the same. Share images of your work and information about exhibitions featuring your work. But don't use social media solely as a promotional tool. Did you see a great show recently or come across a new favorite artist? Did you read an interesting article or learn about a great opportunity? This type of sharing is helpful, reciprocal and appreciated. If you get in the habit of sharing information, people will want to network with you.

And keep in mind, your personal identity and your identity as an artist are intertwined online and that line will blur more and more as your career develops. Don't use social media as an outlet for negativity and frustration. Don't pick apart other people's work or trash talk online. It isn't amusing or provocative. It's unprofessional, unproductive and destructive. Simply put, no one wants to work with a jerk. If you're a bit of a jerk in real life, I recommend trying to keep that fact to yourself. When engaging with others online, do your best to keep it positive, helpful and interesting.

So the next thing I'm going to ask you to do, immediately, is to start participating more actively with your close community and building up your network of wonderful artists and arts professionals. Keep in mind what you can do to be helpful. If you hear about an open call your friend's work would be perfect for, forward the information. If a friend is included in an exhibition, show up to the opening and congratulate them. If it's an online friend you've never met in person, say hello. If someone asks you to do a studio visit and give them feedback, make time and be constructive. If someone is too shy to attend an opening alone, tag along. If you find a great resource for frames or stumble on a fabulous art supply sale, spread the word. You should never demand anything in return. If you build a network and engage in a healthy and positive way, I think you'll be pleased and surprised by the amount of good will and opportunity that will begin flowing your way.

I'd be remiss not to end this section with a quick note about career progress. Referencing other artists' experiences and prices when you are starting out can be helpful. But every career develops at its own pace. Don't get caught up in comparing yourself to others. Don't begrudge anyone else's success. Don't take your success for granted or let it go to your head. Make good work. Build, honor and support your community. And never stop growing your network.

Chapter Five
Support Materials

Yes, making art is the most important part of your job. But maintaining clear, attractive, appropriate materials that support your art is key to getting your work, and your ideas, out to an audience. Every artist should have, at minimum, a website, an up-to-date resume (also referred to as a CV or Curriculum Vitae), a bio, an artist's statement, an "elevator pitch" and a simple business card with your name, website and contact information. Every time you have a solo show, you'll also need to write something about that particular body of work.

I know there are those of you who like to "let the work speak for itself." But if you expect art dealers to try to sell your work, or engage critics or curators, you've got to give them something to talk about. Give them nothing and there's not much they can do. Arm a gallery with terrific work and helpful information about you and your intentions, and that gallery is one step closer to making some magic happen. Once you have clear, concise, terrific support materials; you can get right back to making art. So your next step in this process is to get your support materials together.

Website

I highly recommend you create and maintain your own website using

one of the many available platforms such as Squarespace, Other People's Pixels or Wix. Explore what's out there and see what you like best. If you've never made a website before, and need to get help building it, just make sure you have all of the access and information you need, and understand how, to update the site yourself. You do not want to be dependent on anyone else for changes.

Your website should highlight your work. If you don't have a website already, keep the guidelines below in mind as you create yours. If you do have a website, and it doesn't meet the criteria below, revise and relaunch.

- The minimum your website should include is images of your work, a CV and a way to contact you. Decide for yourself if you want to include your phone number. Some artists choose not to - and that's OK - but always include an email address or contact form. You can also include your bio (with or without your picture), artist statement, a section with news updates, even a blog. Many artists include links to their Facebook, Twitter, Instagram, etc. which is a great idea. Some artists who sell merchandise have a store component. You can also share links to friends' websites. And finally, I love to see an invitation to join an artist's mailing list on their site. A form the visitor can fill out is best, but even if it's just the words "Send me an email if you'd like to be added to my email list" on your contact page, it's terrific to have a call to action. But the three things you absolutely must include are images, a CV and contact information. If you're overwhelmed, just start there.
- The design should be simple - really, really simple. Avoid using distracting colors or a decorative background that competes with your work. I prefer a simple, white background. The idea here is to highlight your artwork, not your personal style or design skills.
- The site and images should load quickly. Navigation should also

be quick, clear and easy. Curators and gallerists are busy. If you're fortunate to have someone want to visit your website, they need to be able to access the information they are looking for in the first few seconds. Don't make anyone work for it with slow images or confusing navigation.

- Your website should not be an archive of every single piece of art you've made since kindergarten. It should include your absolute best work and work that represents what you are doing now. Better to have a website with ten great images and leave a curator wanting to see more, than junk it up with older, less impressive work or work that isn't relevant to what you're doing now. That said, make sure you *do* maintain an archive offline of every piece you've ever made (maybe not since kindergarten but since you started making art seriously).
- Be sure to include the title, size, medium and dimensions of each piece on your website. Someone might be looking for works in a particular size range or medium. You don't want to miss an opportunity because that information wasn't available.
- If you want to exhibit in galleries, do not include prices of your original artwork, or sell your original artwork, on your website. If you have a store with merchandise, that's fine. However, I strongly discourage you from selling or pricing your original artwork online. This will turn galleries off immediately and you will miss opportunities to exhibit as a result. If someone is really interested in your original art and wants to buy something, find out prices, or know how to make a purchase, they will email you and ask.

Resume / CV

As far as your CV is concerned, take a look at other artists' resumes online. You'll notice that content and formatting varies drastically.

Whatever font and layout you choose:
- Make sure your CV is well organized and easy to read.
- Your CV should include, at a minimum, your education (if you have a degree or training), solo exhibitions and group exhibitions. For the exhibition listings include the year the show took place, the title of the show, and the name and location of the venue or gallery. If a show was curated by somebody particularly well known or interesting, you might want to consider including that information also.
- Beyond education and exhibitions, you can also include your date and place of birth and where you live, if you like. If you have won any awards, been written up or included in any catalogs, list those also. Right now you probably need to fluff your CV up a bit. Go ahead and list everything. You can always edit your CV as time wears on. And you *will* want to edit it. Hopefully your resume will fill up quickly. Then you can start to omit the less impressive shows to make room for recent and better ones. As with your image archive, make sure you always keep a complete version of your CV, one that includes every single show you've ever been in, for yourself. You are your own record keeper and you'll be surprised how easy it is to forget the name of a group show or a gallery that's been closed for five years. It's important to keep track. You never know when you'll need to access information about a long ago exhibition.
- And if you've never been in any exhibition and have no formal training, don't worry. Just include a bio on your website for now and keep these guidelines in mind as you build your CV.

Bio & Artist Statements

When it comes to your bio and statements, don't get too hung up on sounding smart or using a lot of art speak. Most people just want to

understand and learn about you and what you're doing. They don't need to be dazzled with obscure art historical references and four-syllable words. I'm not saying those things aren't nice if they are relevant and make sense in the context of what you're writing. But don't make yourself crazy. A clear communication of what you are doing is worth more than a jumble of polysyllabic nonsense.

If the idea of doing this terrifies you, consider asking a friend who writes well to help you. They can listen to what you want to communicate and write it up for you. Or ask them to edit a draft you write. Depending on how well you know them, ask for help as a favor, offer to buy them a meal, pay them in cash or even trade them for a small piece of art. Whatever you have to do, make sure you have a professional bio, and statement you feel comfortable with, ready to go at all times.

A bio should include where you were born and grew up, where you went to school and any important or interesting exhibitions or experience. It's kind of a longhand version of your resume, often with a bit more info. An artist statement is more about what your influences are and what you are trying to accomplish or say with your work. More and more I'm seeing artists fuse the two into sort of a this-is-who-I-am-and-what-my-work-is-about hybrid. I think that works well. Again, your best resource for reference is checking out other artists' bios and statements online. If you see one you like, use the basic structure as a template, swapping out their information and writing style with your own.

If you are fortunate enough to secure a solo exhibition, most galleries will ask for a statement specific to the body of work you plan to show. They will use this as a basis for the press release and to educate themselves and their staff. Even if nobody asks you for a statement, I recommend writing one. The experience of putting your thoughts to paper will help you clarify concepts in your mind so you can better speak about the work. You'll also have the information on hand if

anyone asks for a statement last minute. Some galleries will write a statement for you based on a conversation about the work. It just depends on the relationship and situation. However it gets done, just try to have fun with the process and focus on communicating your ideas. What inspired you to create this body of work? What were your influences and/or references? What are you trying to share, accomplish, inspire or express?

Elevator Pitch & Business Card

An elevator pitch is a business term for a short, concise, engaging description of a product, service or idea. You are supposed to be able to deliver it in the time it takes to ride in an elevator with someone you want to impress. It's a cheesy term, I know. But being prepared with a quick, compelling description of your work will come in handy in many situations. Consider this:

You're at an opening, your sister's wedding, a bar, wherever. Someone asks you "What do you do?" You reply, "I'm an artist." Most of the time the response will be "That's cool." But every once in a while someone will take an interest. You should be able to express clearly in just a few sentences what medium you work in and what your work is about. The last thing you want is to be introduced to an artist you admire or a gallerist, dealer or curator you'd like to have a conversation with and stumble over your words. So, picking up where we left off.... You respond to the interested art lover with your elevator pitch. Something like...

"I create large charcoal works on paper exploring man's innate, yet ultimately self-destructive drive to dominate the natural world."

Maybe they ask you a few more questions and it evolves into a real conversation. Maybe not. But hopefully, at some point, an interested person will ask if you have a website. That's when you hand them your simple, elegant, funky or freaky - as long as it's easy to read - business

card. Minutes, hours or days later they will find the card, visit the wonderful website you worked so hard to create, and just possibly become a fan of your work. Maybe they'll even sign up for your email list.

Whenever you are included in an exhibition, you can expand your elevator pitch with a bit more information. If it's a group show, add a sentence about the particular piece or pieces in the show. If you have a solo show, add a bit about the body of work as a whole and possibly even a few individual pieces. For instance "I create large charcoal works on paper exploring man's innate, yet ultimately self-destructive drive to dominate the natural world. This piece refers to the recent developments..." Or "... This body of work was inspired by a trip I took to... where I saw..." You get what I mean. Showing up at an opening prepared with talking points will help make your evening more enjoyable and less nerve-racking.

Part Three: *Your Studio*

Chapter Six
Creating a Productive Space

Whether it's a roomy warehouse or a tiny corner in your bedroom, your studio is your sacred space for making art. Treat it, and everything that happens there, with respect. Organize your materials and time well. Make sure you have proper lighting and ventilation. Really think about how to get the most out of the space you have. If what you have isn't working, find ways to adapt, and start thinking about what your ideal space will be when an upgrade is eventually possible. Make time to create new work and be prepared, at any given moment, to host a studio visit.

I've known artists who dream for years about having a studio outside of the home and then the minute they can afford one, find they are utterly unproductive in their new environment. I've known others who don't want to travel to a studio, but find the distractions of day-to-day life make it impossible to get anything done at home. Some people work well with music and other people in their space. Others need quiet and solitude. I know several artists who listen to books on tape while they work. An artist who knows what works for them, and isn't always struggling to get things done, enjoys a definite advantage over those who can't quite get a productive groove going. You may not have the ideal studio situation now, or even know what that looks like. Don't let

that stop you. Keep an eye on when you are most productive - what time of day, under what circumstances, and set the goal of creating a studio environment that works well for you. A few things you can work on immediately to create an optimal environment are the lighting, atmosphere, organization, ventilation and safety in your studio.

As far as atmosphere and lighting go, I recommend working on a white table or setting your easel up against a white wall. Most galleries have white walls and this is the background your art will be showing against. Down the line when have a solo show, if you want the walls painted a special color, you can discuss that possibility with the gallery. For now it's safe to assume your work will most likely be hanging on white walls. Also, consider lighting. I know an artist who likes to create a boudoir kind of atmosphere in her studio with sheer drapes, blue walls, a cozy couch and low lighting. But the spot where she paints is against a white wall with a floodlight that simulates gallery lighting. The vibe in the studio makes her feel comfortable and inspired, but everything she creates will also look great in a gallery setting.

Getting and staying organized can help ensure you maximize the time you spend in your studio. Some of us just naturally work messy and that's OK. But you don't want to waste time looking for things. If day after day you can't find what you are looking for, or are struggling with your set up, take a few hours to reorganize. You'll make up the time soon enough.

Make sure your space is safe and properly ventilated. The last thing you want is to hurt yourself via an accident or make yourself sick breathing unhealthy fumes. Store and dispose of toxic and flammable chemicals properly. If you smoke or use a space heater, be careful and smart. Also make sure the area is secure from theft or break-ins, that you trust everyone you share space with, and any studio mates are also careful and responsible.

I recently spoke to an artist who was struggling to get work done.

This artist has young children in school and his wife works outside of the home. His preference is to work alone without distractions. So the best time for him to get work done is during school hours. He set up a functional studio at home, but quickly realized that between pets, deliveries and the pressure of things that needed fixing or doing around the house, he wasn't getting anything done. He shared his struggle with his community and within weeks was referred to the friend of a friend who had a small studio about ten minutes away. Turns out this acquaintance was a talented night owl, trying to dedicate more time to her fine art career, but having trouble covering her studio rent. After meeting the other artist and considering the space itself, he agreed to share the studio. He comes in during the early part of the day and she works at night. They each keep their areas clean and tidy. Occasionally they overlap when one of them has a deadline crunch, but they respect each other's space when that happens. The artist who was struggling to get work done at home now has a terrific workspace and fewer distractions. He's getting more, better work completed and accepting more exhibition invitations. As a result, he's selling more work and easily covering his half of the studio rent. The artist he's renting from was able to hold onto her studio, cut down on freelance design work, and spend more time painting. These two are also networking with each other, and sharing opportunities and information. This is a great example of two artists recognizing their studio challenges and finding an excellent solution with the help of a mutual friend/their community.

Chapter Seven
Task & Time Management

If you're doing it right, there are many, many tasks involved in running your studio. You have to keep track of deadlines, correspondence and artwork. That artwork may need to be framed or otherwise finished. You've got a million receipts and various expenses. Then there's that networking I keep bugging you about - and will continue to because it's important.

As I mentioned in the section about support materials, you should absolutely maintain your own website. You should also do your own social media. Beyond that you'll have to decide, based on your skills and finances, what to take care of yourself and what to pay someone else to do for you. I, personally, think you should at least know *how* to do everything yourself, and do it well. Once you have a good idea of how your studio runs, you can weigh the time vs. savings equation and, when resources allow, outsource what makes sense. However, initially I recommend you try to handle all of your tasks in house. Doing the jobs yourself, at least for a while will sharpen your skills. This is one of the many times a community of artist friends will come in handy. If you have no idea how to light and shoot a piece (neither do I), what receipts to keep (all of them), or how to pack art (very, very carefully) ask your community of artist friends for advice or look it up online. And don't cut

corners. Research and learn how to do things properly. You may even want to consider looking for freelance, part-time or short-term work or intern opportunities where you can pick up the skills you need. For instance, if you want to learn how to frame, pack art or stretch canvases, look for a job where you will be around people doing that or ask if you can help out someplace for a few days in exchange for instructions. Soon you'll be running your studio like a professional, which will help you stay on top of deadlines and better appreciate the professionals you eventually do hire. I also highly recommend every artist spend some time behind the scenes at a gallery. Whether it's interning while you're in school, helping a friend with a show he or she is curating, or volunteering at a nonprofit space, there is no better way to understand the gallery side of the business than to witness mounting an exhibition from the gallery's perspective.

Time management is a topic that comes up frequently when I speak with artists. So many lament not having enough time to create new work. Then once I dig in and really talk to them about what's stopping them, the problem is often time management not lack of time. You should be spending as many hours as you can in the studio, within reason. Most artists I meet spend anywhere between ten and sixty hours a week in the studio. If you can't make time for ten hours a week, you need to look at changes you can make in your daily life to carve out more studio time. Inspiration is also a factor. If you're regularly spending more than sixty hours in the studio, there's no way you are making time to get out, see art, interact and find inspiration in everyday life and culture. However much time you have, you will need to dedicate and organize those hours in order to be effective. I know all artists would much rather be making art. Unfortunately, there will always be tasks that simply must get done in order to move your career forward.

I believe every artist should spend 75-85% of their studio time

making art and the rest on tasks like updating their website, cataloging their work, writing, networking, correspondence, research, keeping the studio stocked and organized and taking the occasional day trip to go check out galleries and shows. This percentage may ebb and flow. You may spend an entire week on your website because it *must* get done. You might have an exhibition deadline and end up spending 100% of your time finishing the art over the course of a few weeks. But on a day-to-day basis, the 15-25% for everything else equation is a good rule for most artists. Some prefer to spend the first few moments or hour of every day warming up with administrative tasks. Others prefer to carve out a full day now and then. But switching back and forth throughout the day without focus is not productive. By organizing your time, you can more fully devote yourself to each task at hand without distraction. Before moving on, consider making a schedule. Look at the amount of time you can, realistically, spend in the studio each week. When can you best put 15-25% of that time to use? What can you do during that time to move towards your goals?

An artist recently told me an inspiring story. About a year ago she found herself in a position where she could more fully dedicate herself to her studio practice. She was committed to taking her career to the next level. She had clear goals and decided to dedicate one out of every five days in the studio to all of the non art-making aspects of building her career. As someone who loves to paint, taking time away wasn't easy. But she trusted that it would be time well spent.

She made a schedule and spent those hours working towards her goals. She attended arts-related events and committed to meeting new people in person and online. Through research and networking she learned about, and was able to participate in, several groups shows. She built her own online store and began selling merchandise, which eventually helped offset her costs. Through productive use of social

media, she went from just a few hundred Facebook followers on her artist page to over 10,000. She now feels connected to a community of supportive and like-minded artists who share information. She is looking forward to another successful and exciting year, this time with the goal of nailing down a solo show. Her story is a great example of what can happen when you identify, prioritize, and make time to pursue your goals.

Chapter Eight
Studio Visits

You may go your whole career without ever hosting a formal studio visit, but I doubt it. Many curators, consultants and gallerists use studio visits as an opportunity, not only to see an artist's work in person, but also get to know them a little and gauge their level of dedication. In addition to formal studio visits, many artists find inviting colleagues over to share ideas and give critiques extremely helpful. If you think you might benefit from hosting a colleague, give it a try.

Your primary responsibility when hosting a studio visit is to be a gracious and considerate host:

- Make the visit worthwhile. You should have at least two or three finished works and a few more underway to justify a studio visit. If someone asks if they can come for a studio visit and you don't have enough to show, tell them you'd love to have them over, but are just finishing up new work. Ask if you can contact them once you are ready. Then don't drop the ball or let too much time go by. Get to work and follow up as soon as possible.
- Be prepared. Take a minute to get organized before your guest arrives. Have the works you want to show, or the visitor is interested in seeing, on display. Know where other important pieces are stored in case the conversation creates an opportunity,

or the need, to pull out additional work.

- Manage your expectations. Rarely will someone offer you a show during a studio visit. What is more likely to happen is they will ask you some good questions, give you some constructive feedback, and keep you in mind for future opportunities. It's perfectly OK to tell a curator or dealer that you like what they do and would be thrilled to be included in a show. Just don't ask "So, are you going to put me in a show?" at the end of the visit. Let them invite you.
- Treat your visitor like a person. Ask questions if you have questions. Offer them at least a glass of water and a clean seat. If you have pets in the studio, let them know ahead of time in case they are allergic or afraid. Make appropriate arrangements if that is the case. If your studio runs really hot or really cold, mention it so they're prepared. Simple considerations will make your visitor more comfortable and lead to a better visit. When I was a gallerist in New York, I'd pack several studio visits into a single day. I'd wake up early on a day the gallery was closed and see four or five artists, schlepping in rain, snow or heat on the subway and in cabs. It was often inspiring, always exhausting, and sometimes the visits ran long and the whole day would back up. I always appreciated being offered a glass of water, cookie or some other little snack. I also rarely turned down a beer or a glass of wine, particularly towards the end of a long day.
- Be safe. If a collector or other unknown person (or person you don't know well) contacts you and wants to visit, use your judgment. Never be alone with anyone you don't feel 100% comfortable with. You can still book the studio visit gracefully. Just ask your studio mate to be present, or if you have a solo studio, ask a friend to sit quietly at a laptop in the other room or close by. Just tell the guest your friend is helping you update your website or catalog work.

Part Four: *Exhibiting Your Work*

Chapter Nine
Finding & Approaching Galleries

So you've got great work, a fantastic website, you can talk about your work, you've got a groove going in the studio, you're managing your time, you're building a network. Now what? Well, it's time to get your work out there. I know how intimidating and abstract that can seem. It's also very exciting.

The first and most important thing to keep in mind - and I know I've said this before - is that it's a great big art world out there. So how do you get your work seen? There are several ways. To begin with, there are traditional commercial galleries (and as I've mentioned, countless different levels and versions of those), nonprofits, alternative and artist-run spaces, juried exhibitions, competitions and art fairs. You can get together with friends and mount your own exhibition or participate in open studios. There are dozens of options. And there's really no way of knowing how this next step is going to go. That's why I suggested that your first, twelve-month goal be "Make good work and share it." It's vague enough to allow lots of room for experimentation and also success. Whatever your goals, once you start participating and connecting with an audience things might go exactly as you'd hoped. Or they might evolve, organically, in surprising ways. But your work isn't going to get in front of people all by itself. So your next step is to dive

in, work tirelessly on research and outreach, be super patient with the process and start getting your work seen.

Finding & Approaching Galleries

It's important to identify which galleries are appropriate for you before you submit your work. Submitting to galleries that aren't a good fit wastes everyone's time, invites extra, unnecessary rejection, and could alienate a gallery that might one day take an interest. So how do you figure our which galleries are appropriate? Ask yourself these questions:

- Does this gallery show the kind of art I make? For instance, if you're a painter and it's a photography gallery, or you're a representational artist and they show only abstract work, move on.
- Does this gallery show artists at my level? Don't shoot for the moon right out of the gate. Find galleries that are willing to work with emerging artists.
- Is this gallery taking submissions? Many do not. I know it's frustrating to feel like you are perfect for a gallery and then learn they aren't taking submissions. But if a gallery isn't accepting submissions, don't submit your work anyway. If you're determined, try to find another way to get on their radar.

So how do you find these magical galleries and venues that are appropriate and open to taking submissions? Do your research:

- Visit as many galleries as you can, as frequently as possible. If you're in a big city, hit every neighborhood with galleries. If you're in the suburbs, or a smaller town within driving distance, take a day trip to see what your closest metropolis has to offer. If you find any local galleries you like, see every show. Any time you travel someplace new, prioritize visiting galleries. Keep in mind that just because one show looks like a fit, doesn't mean it's representative of the gallery's overall program. You should still

check out their website afterwards. But there's no better way to familiarize yourself with a gallery than experiencing the space in person.

- Keep your eyes and ears open for names. Any time you see or hear a gallery mentioned that you don't recognize, visit that gallery's website. You'll be surprised how quickly you'll become familiar, not only with the galleries, but the nuances, levels and types of galleries, out there.
- Search for art blogs you like and browse well-stocked magazine stands. Familiarize yourself with the art blogs and magazines that seem relevant to your work and goals. Look up the galleries they mention and where the artists they feature are exhibiting.
- Research where artists you respect have shown and are showing. Where did that big artist whose work you love get his or her start? Where are your colleagues showing? Sign up for all of your friends' and colleagues' email lists so the information comes straight to your in box and you don't miss any announcements.
- If you live in or near a city that hosts art fairs, they are an excellent way to check out a bunch of galleries in a short period of time. If you're in a very big city, like Miami or New York, don't scout the bigger fairs like Armory or Art Basel. Stick to satellite fairs like Aqua, Scope, Pulse and Red Dot where younger, more emerging artists are being shown. Take a day to tour the fair or fairs. Bring a small notebook. Pick up business cards and write down the names of galleries and artists you like. Then go home and look them all up. Do not approach, bother, or otherwise distract any person working in any booth at any art fair, ever. Galleries do not appreciate being approached at fairs. Just walk around and do your research. If you can't visit art fairs in person, go to their websites and explore each fair's list of recent exhibitors. New art fairs open and others close, but start with those

I mentioned and see where that takes you.

So now you've got a list of ten, twenty, fifty galleries that are appropriate for your type of work and level of experience and interest you. The next step is approaching them. Here are some tips:

- Some galleries will state clearly on their website that they accept submissions. If they offer instructions, follow them precisely no matter how ridiculous they may seem. This is your first chance to demonstrate that you are professional and courteous. If no instructions are given, or they don't indicate whether they are accepting submissions or not, I recommend emailing a short note. Start with... "I just finished school at..." Or "I was recently in your gallery and loved it... " Move on to "I've shown at XYZ..." Or "I'm eager and excited to begin exhibiting..." Tell them what you want. Something like... "Please consider me for any group or solo exhibition opportunities..." If you've sold your work mention that too... "My work has been selling regularly..." Or "I was recently included in X show and my piece sold opening night..." And then wrap up with... "Please visit my website at the link below." Provide them with a link to your website and all of your contact information. Attach one or two low-resolution images, just to give them a quick idea of what your work is like. Include the title, year, medium and dimensions for those works. Then blow a kiss to whatever art God you pray to and hit send.

- If you visit a gallery and the person behind the counter is busy or putting out a "don't bother me" vibe, don't bother them. And don't pose as a potential client to strike up conversation. If they seem friendly and approachable, by all means, ask if the gallery is accepting submissions. If the answer is yes, take a card and follow up. If the answer is no, but the person asks you for a card anyway, give them one happily. A lot of galleries aren't looking for new artists but the owner, director and/or staff is still interested in

keeping track of what's happening. The more people you can get looking at your work, the better. It could lead to something down the line.

- Start frequenting the galleries you like, even if they aren't taking submissions. Gallerists are people too. We appreciate you showing up. If you like a show, compliment the curator, gallery or artist. Everyone appreciates a kind word. Become part of that gallery's community. Try to see every show. I've built relationships with artists who frequented my gallery, visited their studios, and passed along information about opportunities that might suit them. If you like a gallery and like what they show, it's worth making the effort.

- Sign up for lots of gallery email lists and follow them online. You don't want to miss out on the opportunity to submit to an open call at a gallery you love because you missed the announcement.

- Everywhere you go - parties, galleries, bars, bar mitzvahs - always have business cards with you and your elevator pitch ready. You never know who you'll meet. Sometimes opportunities step right out in front of you. You should always be ready to pounce.

Rejection & Follow Up

I know rejection sucks. Please keep in mind, and I promise this isn't just a line; it often has nothing to do with you. If you submit to a gallery that is taking submissions and really is an appropriate fit, you could be passed over for any number of reasons. Perhaps that gallery just added an artist to their program whose work is too similar to yours. Maybe they're in the middle of lease negotiations and waiting to book shows or add new artists until things settle down. Maybe they have a new director coming in and need to wait to see how the overall program is impacted. Maybe they plan to move their program in a different direction. You just never know what's going on behind the scenes. Don't let rejection crush

you. And don't give up. Persistence is one of the most important factors in building and sustaining an art career.

Artists often ask me what's appropriate when it comes to follow up. If a gallery tells you the work isn't a good fit and/or they are not interested, accept that and even if you disagree, move on. Only resubmit if the direction of the gallery changes drastically enough to warrant reaching out again. Often times a gallery will say they like your work, but don't have any opportunities now and will "keep you on file." They might be trying to brush you off or it might be true. I say consider it a "maybe down the line." Add them to your email list or create a list of galleries that have been somewhat encouraging. Then when you have news to share, such as a new exhibition you'll be part of, or an entirely new body of work on your website, include them on an email blast or send a personal email. It's a great way to stay on their radar without being too intrusive. You might also consider printing old-fashioned postcards and mailing them. In this age of electronic communication, an attractive announcement in the mail will stand out and just might catch the attention of the right person on the right day. I know a few artists who mail announcements whenever they have a solo show, even to galleries they like that aren't taking submissions. After all, it's an invitation, not a submission. I never minded getting postcards in the mail when I had my brick-and-mortar space; particularly from artists I'd had some previous interaction with in the gallery or community.

Chapter Ten
Curated Shows & Competitions

Many artists think the only way to build a career is to connect directly with, and exhibit at commercial galleries. There are plenty of other ways to get your work seen such as curated exhibitions, fundraisers, calls for entry, juried exhibitions and competitions.

Curated Exhibitions

With curated exhibitions, artists are invited by the curator to participate and there is no entry fee. These shows are a great opportunity to get your work seen and to meet new people. The best way to find curated exhibitions is to network with other artists and curators. Support curated exhibitions by following young curators and attending their shows. Many young curators are enthusiastic, open and interested in discovering new artists. If you meet someone who is curating interesting shows, tell them you like what they are doing. Invite them for a studio visit, and ask them to take a peek at your website and keep you in mind. You should also, and we'll get into this in a future chapter, consider curating or co-curating an exhibition yourself.

Fundraisers

You will undoubtedly come across many fundraising or charity

shows over the course of your career. Schools, institutions and nonprofits use exhibitions to raise funds for their programs. Individuals or groups often put fundraisers together to raise money for disaster relief or a specific cause. If you hear about an interesting charity exhibition, reach out and see if they still need work. It can be a great way to network while contributing to something positive. An artist once told me his first charity exhibition was one of the high points of his career. Seeing his work hanging next to artists he admired boosted his confidence and supporting a charity he believed in gave him an easy conversation starter at the gala. Things to consider with fundraisers are:

- Where is the money going? Is it a reputable organization or charity? Is the cause in alignment with my values? You never want your name attached to something shady or a cause you don't agree with spiritually or politically.
- What am I being asked to donate and what is the sales structure? Sometimes these shows have an auction component. Sometimes it's a more straightforward exhibition format. Some shows will ask you to donate the piece entirely. Other times the host gallery will donate all or a portion of their commission if your piece sells. Sometimes the organizers will ask that you donate a percentage of your commission. It varies so be open. Just make sure you understand, and are comfortable with, what's going to happen from a sales standpoint.
- What happens to my piece if it doesn't sell? Will I get it back? If not, who gets it and/or where does it go? As a rule, you should always keep track of your art, wherever it goes.
- Is there a fee to attend the reception or event and if so are the artists invited to attend free of charge? If it's a fancy event people are paying to attend, you definitely want to go. There will be snacks and drinks and all sorts of people to meet.

Calls for Entry & Competitions

An exhibition where you submit work for consideration in the hopes you'll be selected is usually referred to as a Call for Entry or Juried Exhibition. You'll find mixed opinions about these types of shows because many require an entry fee and the quality varies. But there are some good shows out there and it's definitely one way to build your exhibition history, and gain experience and exposure. These shows are also easy to find. At the end of this book you'll find a list of websites that collect and share information about these types of opportunities. There are also regional lists you can access. Just search your city or region along with keywords like "artist opportunities" and "call for entries." Some lists have a subscription fee and send you emails. Others you can search for free. Check out several. Join and/or revisit the ones you like. Keep the following rules in mind when deciding which exhibitions to submit your work:

- Check the requirements closely. Many exhibitions have specific parameters. For instance, they're only open to artists from a specific area or working in certain mediums. You don't want to waste time or money submitting to the wrong shows.
- Beyond the listed parameters, evaluate the theme and the curator's taste. If you don't know the curator, look them up. Be selective and submit to a few shows you have a very good chance of getting into rather than several you probably won't.
- You'll find these types of opportunities pop up at a variety of venues ranging from innovative nonprofit institutions to small museums to commercial galleries just looking to make a buck on the entry fees. Research the venue and let that factor into your decision. If you're a great fit for a show at a museum, submit your work. A museum show, even at a small, rural museum, always looks good on a resume.
- Don't spend a lot of money and be careful to whom you give your

money. If a reputable, nonprofit space requires a reasonable fee (say $40 or less), and the money is going towards supporting that institution or mounting the exhibition, that's one thing. If it's clearly a moneymaking proposition for the exhibition host, be more discriminating.

- Read the fine print. If you're accepted, is there a fee to participate? That's a big red flag. What about shipping? It's standard for the artist to pay to ship work to a venue and for the venue to pay to return unsold work. If you're required and willing to pay for shipping both ways, that's fine. Just try to determine before applying if you'll be expected to cover any additional or non-standard costs.
- Keep your goals in mind. For instance, let's say Art Dealer X owns a gallery you would love to show with, but they aren't taking submissions. You notice that same dealer is curating a show with a nature theme at a local nonprofit to raise money for the botanical gardens. You have some terrific nature-themed works. It's $25 to submit to the exhibition. Maybe you aren't a huge fan of the exhibition space. But would you pay $25 to have Art Dealer X look at your work? Yes, you would. So, as long as you have appropriate work (remember, you never want to waste anyone's time) submit to the show. If you don't have an appropriate piece finished, but have the time and ability to make something that meets the parameters while still representing you as an artist, make a new piece. Maybe Art Dealer X will like your work and remember you for his own gallery. Maybe he won't. Maybe you'll get into the show. Maybe you won't. But he will see your art and that's valuable. It's worth mentioning that some shows are blind submissions. That means the curator(s) won't see your name when they evaluate your work for the show. They will see your name if you get into the show. And if for some reason you don't, but

they're interested, the curator can access that information.
- Don't bother with online-only exhibitions. Stick to shows where your work will be exhibited and seen in person.

Competitions & Juried Publications

Competitions are similar to juried exhibitions. You'll find them through referrals, friends and also on the same sites that list juried exhibitions. They tend to be more general but with some sort of award like cash or inclusion in an exhibition. There are also art magazines that host competitions and even juried art publications. As with other opportunities, do your research. Make sure it's a publication you'd want to be associated with, or featured in, before submitting. And then apply the general rules above and be very careful of the fine print. Some charge to be included once you've been accepted. *New American Paintings* is an example of a publication that does not. The issues are organized by region with a different curator/juror each issue. It's $50 to submit and there are no additional fees. It's a blind jury process but many curators, galleries and collectors browse *New American Paintings* to see who is selected.

Chapter Eleven
Other People & Places

Unless you have a visitor, your work is doing nothing for you sitting in the studio. Think about who you know with walls where you can hang your art for people to see. Sure, there's the local cafe. By all means, ask them. But who else? Any retail store from clothing to furniture to a flower shop is a candidate. Also, places where services are performed like a beauty salon. Just make sure your name and contact info are displayed or accessible. Here's a recent story in support of getting your work out there:

I was helping an LA based colleague source new artists for a corporate project in New York. I was in Seattle for a wedding and happened to see some beautiful paintings in a coffee shop. I took the artist's information and passed it along to my colleague. She visited the artist's website and loved the work. Whether or not her client decides to buy something, my colleague and I now both have the artist's name, website and information on file for future reference. You never know what could happen, but neither of us would have discovered that artist if her work hadn't been hanging in that cafe. As long as your work is presented well and treated respectfully, it's worth getting your art out of the studio and onto walls in your community. Which brings us to all of the other people who can help get your work seen.

There are probably as many consultants and private dealers in the art world as there are galleries, maybe more. These individuals may work for one or more collectors, corporations or foundations finding art to buy. Some work for themselves, offering art to different clients, earning a commission if they sell work. There are different types and levels of consultants and private dealers. Some do focus on emerging artists. Many are charged with filling an entire home or building within the confines of a budget and to the tastes of their client. It's the job of these dealers and consultants to know who and what is out there so that with each new client or situation they are armed with ideas and suggestions. You will be absolutely shocked by the number of results you get online using the search term Art Consultant. You could spend weeks weeding through them and, as with everything else, some are better than others. But be aware that they are out there, can be wonderful allies and are usually more open to looking at work than galleries. Most have projects, clients and affiliations listed on their websites. As you network more you will undoubtedly come across a few. You can also ask around about consultants and dealers and see if anyone you know has worked with one.

Once you're ready for studio visits, consider reaching out to a few consultants in your area and inviting them. It can be good practice and less intimidating than a gallery visit. Consultants get paid differently depending on the situation, so if they want to offer your art to a client, make sure you understand how they work. If they will be extending a discount to their client, which is common, you should still net at least 50% of the sale price. Also be aware that payment can be tricky. Often times they won't pay you until the client pays them and the client won't pay them until the work is delivered. Sketchy, right? That's why being comfortable with the people you are dealing with is so important. Get the sale terms in writing and don't be afraid to ask around about a consultant before doing business with them. And don't limit yourself to

just art consultants and dealers.

Consider who else you might know or meet who can help you get your work seen. Interior designers can be a terrific resource. Are there any in your family, community or network? Ask them if they ever need art for clients and invite them over for a studio visit. Do you know any realtors? They often "stage" empty homes with furniture and art to make the properties more attractive to buyers. If you know anyone who might be willing to stage a house with your art, let them know you're interested. How about a friend who rents their place through a service like Airbnb? Lend them art for their walls and ask that they leave cards out when the place is rented. Chances are there will be plenty of people and places in your life, now and in the future, with whom you can develop reciprocal relationships. You supply them with art that meets their needs. They help you get your work seen. Always keep your eyes and ears open for these people and opportunities.

If you do show in non-traditional locations or situations, you'll need to consider insurance. There will be many times throughout your career when you'll have to weigh an opportunity against the risk. You should carry renters or homeowners insurance on your home and studio. Ask your broker if your work is covered when it's out in the world and not covered under someone else's policy. Explain the different situations where that could happen. If you can secure a policy that covers you broadly and isn't cost prohibitive, you should. It's the simplest, easiest way to feel comfortable. If you find yourself in a situation where your work might not be covered, it's your call if you want to participate.

Chapter Twelve
Creating Your Own Opportunities

In addition to proactively looking for opportunities, look for ways to create your own opportunities. Believe it or not there was a time when it was frowned upon for an artist to have their own website, curate him or herself into an exhibition or show with several different galleries. The art world is a notoriously late adapter but change is happening. This is a golden time for artists to create their own opportunities. Go for it. Consider curating exhibitions, getting together with friends to put on an exhibition, joining or creating a co-op or artist run space, participating in open studios, and/or hosting studio parties.

Curating Exhibitions

Every artist should understand what it takes to organize and execute an exhibition from the gallery's standpoint. A great way to learn that is to actually put on a show. Curating an exhibition and getting together with friends to put on a show are pretty close, with just a few distinctions and different hassles. In either case you need to come up with a show idea, find a venue, secure the participating artists, get very, very clear on who is responsible for what, manage your responsibilities flawlessly, double check that everyone is doing what they should be doing without insulting them, install the show, promote the show, and

try to sell the artwork.

If you want to curate a show at an existing art space you can approach it one of two ways. You can identify a space you're pretty sure will let you do a show, come up with an idea that is well suited to the space and pitch it to them. Or you can come up with a fabulous show idea and then go out and pitch it to different spaces until you find one willing to work with you. Present a show concept that is original, evocative and memorable, one the host gallery won't be able to resist. Even with a terrific concept, you might only be able to secure space during a slow time of year or for a short period of time. Take whatever you can get. The experience will be worthwhile, regardless of timing.

Once you nail down a venue and dates, invite the artists. Your first time out, stick to a small number of artists you trust to be reliable. I also recommend working with local artists who can drop off and pick up their own work. You don't want to get stuck with a shipping return nightmare when it's all over.

Before things get started, make sure you are very clear with the venue on what you are responsible for and what they will provide. Chances are they've worked with an outside curator before. Ask them what their normal procedure is and unless something sounds really peculiar, follow that. Don't be afraid to ask questions. Most people would rather answer a few too many questions than run into problems down the line. The most common arrangement, with a traditional gallery, looks something like this:

- You deal directly with the artists. Invite them, make sure they have all of the information they need and meet their deadlines.
- You write a press release or share info for a press release with the gallery. They distribute it to their contacts. You send the press release to anyone you know who might have a well-read blog or other outlet for sharing the information.
- You and/or the artists get the work to the venue.

- The space is, hopefully, prepped and ready to go when you get there. You install the show with the gallery's help. If the gallery isn't going to help you install, make sure you know where everything is and get some friends to help.
- Everyone - you, the gallery, the artists - helps promote the show any way they can.
- The gallery plans and covers the cost of a reception, which you are expected to attend. You arrive prepared to talk about the exhibition and artwork and enjoy your moment in the spotlight.
- Any sales go through the gallery. They pay you and the artists at the end. The commission structure will most likely be 50% artist, 10% curator, 40% gallery. If you build a reputation as a curator you may eventually be able to ask for a curator's fee or larger percentage. The standard is a flat 10%. Make sure the gallery has contact and/or payment information for the artists who sell work. Then ask those artists to let you know when they get paid. It's a great way to double check that payments happen without making the gallery feel like you're checking up on them.
- At the end of the show, you and the gallery deinstall the work and make sure it all gets back to where it belongs. If any artist is flaky and doesn't pick up their unsold work, you take it and make sure it gets back to them.

Mounting Your Own Exhibitions

A slightly different scenario involves getting a group of friends together and putting on a show that includes all of your work. In this situation, you will have to do more of the work yourselves and go out of pocket on expenses, but you'll have more control and keep more of the money from sales. You can make a budget, agree to split costs and each keep 100% of your own sales, share a % of all sales, or even put a % of the sales towards a fund to put on the next show. Any arrangement that

makes sense for the group is acceptable. If you do a show with friends, just make sure everyone is responsible, trustworthy and knows what is expected of them.

The first thing you'll have to do is secure a location. An empty commercial space can be an interesting venue option. If there are empty storefronts in your city, call the rental agent and ask if you can rent the space short term. You might have to bring in proper lights and you'll need to look into, and secure, temporary insurance coverage so you're not liable if someone gets hurt or something breaks. But depending on the space, it could be worth it. You can also search sites like Storefront that list short-term retail rentals. You'll pay more than you would if you found a venue directly but the spaces are usually clean, well lit and ready to use. Also, don't forget those alternative spaces. Maybe a local cafe or your hairdresser will let you and your friends hang art for a period of time and host a reception. And of course, there's your studio. If you or anyone else in the group has a studio that could be used as an exhibition space, sacrifice the space for a few days to mount a one night or weekend long show. You've probably noticed throughout this book I haven't been using artist's names in examples. I just feel like it isn't appropriate since I'm telling other people's personal stories. I'll break that with the next example since I was somewhat involved and know the artists won't mind.

In 2010, two fabulous New York artists named Jean-Pierre Roy and Michael Kagan got the idea to host an open-call exhibition of artwork on New York City Transit MetroCards in their shared Brooklyn studio. They titled the show *Single Fare*, put out the call and accepted any work that made it in time for the deadline. That's right, ANY work that made it on time and met the requirements was accepted. I even knitted a MetroCard cozy and was thrilled to see it displayed alongside "real" art. All works had to be priced at $100 each and if anything sold the hosts kept a small % to help cover reception and other costs. Friends pitched

in to hang the MetroCard art, the studio looked amazing and the party was packed. Jean-Pierre and Michael had a great time, met a ton of new people, and sold enough art to make a small profit. They also enjoyed providing their community with an opportunity to exhibit and network. In fact, *Single Fare* was such an enormous hit, they went on to mount a second, larger installment at my gallery and then a third, even bigger show, at another gallery in New York. Jean-Pierre and Michael were featured in numerous blogs and publications, including *The New York Times* and *The Wall Street Journal*, for their innovative idea and DIY attitude. As you can imagine, in addition to all of the other wonderful results, the exposure drew quite a bit of attention to their individual careers.

Formal Open Studios & Casual Studio Parties

Many official studio buildings will host regular open studios. All of the artists are invited, and sometimes required, to open their studios to the public. The events are publicized and attract everyone from curious browsers to serious collectors. The quality of the attendees usually depends on the reputation of the studio building and the artists. Keep your eye out for good studio buildings that host well-respected, serious and/or interesting open studios. Also check to see if there are any studio programs in your town that, in addition to hosting open studios, provide free or discounted rent to their artist tenants. Most programs and many buildings have an application process. But it's worth finding, and applying to, any building that has good facilities and hosts events. And even if you end up in a casual building, or one where the open studios are kind of lame, it's still worth participating. You never know who you might meet or what you might learn at open studios.

I know an artist who had a life changing epiphany during open studios. She was in a terrific building, surrounded by talented, hard working artists. Before her first open studios, she toured the building

and while she absolutely loved some of the work, some just didn't interest her. Later that evening, welcoming people into her studio, some visitors asked serious, probing questions and were genuinely interested in her work. Other guests walked right through without even slowing down. But she didn't mind. Everyone had a wonderful time, the open studios were a hit, and the experience made her realize not everyone is going to like everyone's work - and that's OK. It's no reflection on the quality of the work or the artist's commitment. It's just a matter of individual taste. That realization resonated with her and the next day she went into the studio feeling both energized and grounded. She was able to let go of worrying about pleasing others. She felt free to make better, more authentic work, and to share it with more confidence. And she did. I'm sure she would have gotten to the same place another way eventually. But that open studios sped up the process, saving her untold heartache and wasted energy.

Beyond formal open studios, if you have a private or shared studio large enough to accommodate a group, but you aren't inclined or allowed to mount a formal exhibition, you can always host a small, informal studio party. Invite people you like. Encourage everyone to bring a friend. Put out some cheap booze and nibbles. I've been to many casual studio parties over the years. They can be a lot of fun for everyone. For the host they're also a great opportunity to invite people into the studio, share your work, get some feedback, catch up with friends and meet new people.

Community Art Fairs & Festivals

Many communities host annual festivals where artists can rent space and sell their work directly to the public. Some are stand alone events. Others are held in conjunction with larger events like food, wine or music festivals. I don't know of any galleries that frequent these types of fairs looking for artists. I do know artists who participate in these

types of fairs. I've heard from a few that they do very well financially. Others tell me it's just a nice way to meet new people, network and engage with their community.

Chapter Thirteen
Working with Galleries

Once you start exhibiting your work, regardless of the type of venue, the most straightforward path to moving your career forward looks something like this:

- Step 1 - Get into some group shows. Make good work. Meet your deadlines. Be easy to work with, humble, responsible and supportive. Price your work to sell. Help promote the show to your community and network. Refer anyone who approaches you about buying work to the galleries. Your work sells.
- Step 2 - Over time you'll land a two, three, four person or even a solo show. Then you continue to... Make good work. Meet your deadlines. Be easy to work with, humble, responsible and supportive. Price your work to sell. Help promote the show to your community and network. Refer anyone who approaches or asks you about buying work to the gallery. Your work continues to sell.
- Step 3 - You secure one or more wonderful galleries for ongoing solo exhibitions. You also participate in interesting group exhibitions. Now you... Make good work. Meet your deadlines. Be easy to work with, humble, responsible and supportive. Maybe, if you've been selling consistently, you raise your prices a bit. But

you still price your work to sell. You help promote the shows to your community and network and refer anyone who asks you about buying work to the galleries. Your work continues to sell.

Congratulations! You are now a working artist. You have moved on to the next stage of your career, with a host of new challenges to deal with, few of which we are going to get into here. So let's get back to getting you there.

Most galleries, curators and arts professionals work really hard, particularly at the level you'll be working with initially. Most get into the business because they love art and are passionate about supporting art and artists. There are bad galleries out there, as there are bad people in all walks of life. However, the majority of galleries you will come across are run by good people who want to succeed and want you to succeed. The key is to look at every gallery relationship as just that - a relationship - each with its own nuances.

Gallery Representation

Representation used to be a big deal. Every artist's goal was to get gallery representation. What does representation mean? That you are guaranteed solo shows at regular intervals, your gallery seeks out additional opportunities for you, and helps you build your career and resume. The gallery has to approve any other shows you participate in, and any artwork going to another exhibition is consigned through them. They handle all sales, including studio sales and commissions, and you are paid through them. They will also often help manage your inventory, even frame and shoot artwork for you in some cases. Representation can be fantastic if it's a good fit and a good relationship. You know your gallery is strategizing on your behalf. You don't have to chase down money other galleries or people owe you. And there are other benefits. Your gallerist is often privy to information you might not have - like which curator has an interesting group show in the works, and what

gallery might be going out of business or is difficult to work with. On the other hand, I've heard artists complain that once they committed to a gallery, they felt lost in a stable of artists, forgotten except when they had a show. This is probably because the gallery just has too many artists, or they have an internal issue. Whatever the reason, it might not be a good fit for the artist over time.

The past few years I've noticed a lot of terrific galleries aren't bothering to formally represent artists anymore. As long as communication with the artist is open and clear, they don't feel the need. And very few galleries will expect a contract, even if they do represent you. I never represented more than ten artists at a time because that was the most I could handle and I never asked any of them for a contract. If a relationship isn't working for one of the parties involved, why keep it going? My advice to you regarding representation is to *take it slow*. You wouldn't marry someone without dating first, right? Do at least one solo show with a gallery and see how it goes. If it's a terrific fit and you feel comfortable working with them, move forward. Just don't commit to anything before you know what to expect and with whom you are dealing. And never sign a representation contract without consulting a lawyer first and making sure you understand and are comfortable with the agreement.

But before you can even think about the possibility of representation, you have to start building relationships.

Getting to Know You

Your first group show with a gallery is like a first date. You want to make a good impression. If you end up liking that gallery or curator you want the option to interact with them again. The best way to make a good impression is to be prompt and responsible. Trust the gallery's judgment and follow all instructions to the letter. If you don't understand an instruction, *ask*. Meet your deadlines (one of the most

Art Fairs

Artists often ask me how art fairs work. Basically, a gallery applies to an art fair and if accepted brings work by one or more artists to display and sell in their booth. Many gallerists and dealers who don't maintain permanent, open to the public spaces, still participate in art fairs. If pretty much any dealer whose vibe you like asks to bring your work to an art fair, say yes and don't be too picky. Even if it's not the coolest art fair and your work doesn't end up selling, it's a great opportunity. Thousands of people will see your work.

Something to be aware of is that many dealers will object to you having work in more than one booth at the same fair. If you run into this problem, congratulations. You're on your way. Just be sure to check with the first dealer who invited you before agreeing to give work to the second. Then, if they don't mind, make sure the second dealer knows you'll also be showing elsewhere.

If you're included in a booth at an art fair, stop by and say hello if possible. If your dealer is working alone, offer to watch the booth while he or she uses the restroom and ask if he or she needs anything. But don't hang out. Fairs are much more intense than regular exhibitions. They are short, expensive, exhausting and high pressure. Be supportive but give your dealer the space to do his or her thing.

If you do have a relationship with a gallery and they do not include you in an art fair booth, try not to get upset. They might have other artists they've worked with longer and are obligated to include. Also, every fair and city is different. They may not feel confident they can sell your work at that particular fair. Or they may have a curatorial concept for the booth and your work simply doesn't fit. That doesn't mean you won't be a perfect fit next time. Again, art fairs are high pressure. Cut your dealer some slack. Still drop by and show your support for the gallery overall. Hopefully they'll include you in another fair another time.

Chapter Fourteen
Art World Etiquette

The art world is funny. There's no one set of firm rules that we've all agreed upon and you will run up against an incredibly wide range of characters. Add to that the fact that all sorts of people all over the world know each other and it can make navigating the art world challenging. I think an excellent rule of thumb is to just try to put yourself in the other person's shoes. Give everyone the benefit of the doubt initially and treat everyone with the same respect you'd like to be treated. Chances are you'll fall in with a community of friends and colleagues with similar values. But on the occasions when you find yourself in strange and unknown situations, use common sense. A few faux pas I've witnessed personally and haven't mentioned yet include:

Know when to wrap up a conversation, particularly at an opening. If you have the opportunity to meet an artist you admire at his or her opening, or are introduced to the owner of the gallery, make brief, polite conversation, compliment the show if you like it, and move on. If someone cuts you off or wraps up a conversation quickly, it might not be because they're rude. It might be because the collector or critic they've been anxiously waiting for just walked in the door. Remember, they're working. Appreciate and respect that.

If you get invited to a fancy party, after party or other art event, don't

assume it's OK to bring a guest. Ask the host who invited you if you can bring someone.

Be careful what you say and to whom you say it. If someone lies to you, cheats you or screws you over, and you are 100% sure that's what happened, then of course you should warn a friend if they ask. Make sure you trust that person not to repeat it, and if there's any chance they will, you might want to edit out some of the more unsavory details. And if there's any chance you're unclear about what happened, keep it to yourself or be very careful what you say. In the reverse, if a dealer or curator you know little about approaches you about participating in a show, and a friend has experience with that person, call that friend and ask for a reference. If your friend tells you a horror story, use your own judgment about whether or not you want to work with that person. But do not repeat anything you were told. If you decide not to participate, make an excuse about being too busy with other deadlines. Be aware when people take you into their confidence, be worthy of their trust and don't get caught in the middle.

Try not to take mishaps personally and don't let them impact your behavior. If you do find yourself in a bad or upsetting situation, step back, make sure you understand what's happening and keep in mind you never know exactly what's going on with the other person. I can't say this enough: Most of the people you will meet who are involved in making and exhibiting art have the best intentions. Some may have issues or not-so-great personalities but the majority are decent people. And we all have bad days. If someone isn't friendly, maybe their dog is sick. Or maybe they just aren't friendly. If it took longer than anticipated to get paid, maybe they had a plumbing catastrophe and had to decide between letting the toilet explode and cutting checks that week. Maybe they just pay slowly. So give everyone the benefit of the doubt. If you find someone's unpleasant behavior to be the norm, decide if it's worth putting up with to further your career. Just don't let it impact your level

of professionalism and don't take it personally. Of course if someone flat out doesn't pay you or screams at you in public, clearly they're not someone you want to work with again. Wrap things up and move on from that relationship immediately.

Never complain about one gallery to another gallery. It's fine to share, diplomatically, why your last gallery wasn't the right fit for you or your work. Just don't get carried away. If I do a studio visit with an artist I barely know and they start telling me all of the reasons their last gallery sucks and why they left, I can be pretty sure, if I work with them and it isn't a good fit, they'll complain about me to the next dealer. There are lots of good artists out there. There's no reason to run the risk of getting involved with someone gossipy, difficult or volatile. Trash talking will not only make you look bad, it will exclude you from opportunities.

And finally, don't ever take any situation, person or opportunity for granted. You are going to cross paths with people again and again along the way. That ditzy intern just might be the director of a top gallery someday. You never know. Decline opportunities that don't suit you graciously and treat everyone with respect. People will remember that you were nice to them and believe me, they will remember if you weren't.

Part Five: *Selling & Pricing Your Work*

Chapter Fifteen
Types of Sales

Every artist wants to support him or herself full time through sales of their art. I hope that happens for you quickly and easily. This section covers the different types of sales, what to expect and how to determine prices for your work. Unfortunately, most young artists, in fact many artists throughout their lives, will need to supplement their income. I'll talk about ways to do just that, and also touch on budgeting, taxes, residencies and grants in the next section.

Gallery Sales

Our business is pretty casual. You'll have to decide for yourself how diligent you want to get with paperwork and follow up. But there are some basic, accepted practices to be aware of when selling your artwork through a gallery:
- Your work is on consignment to the gallery. You own it and are agreeing that the gallery has the right to exhibit and try to sell it. They pay you only if they sell the consigned artwork and return it if they don't. Some galleries will ask you to sign a consignment form. You are also welcome to supply one yourself. The bare minimum a consignment form should include is the consignor and consignee's basic information, information about, including the

price of, the artwork, payment terms and the length of the consignment. More detailed consignment agreements will also include things like who is responsible for insurance coverage, transportation and legal fees in the event of a dispute. When considering what paperwork you are comfortable with, ask yourself: Do I feel like I have everything outlined clearly in an email (in other words, something in writing)? Do I trust these people and/or is it worth trusting them to be in the show? Is it worth risking putting them off by supplying an overly aggressive consignment form or refusing to sign theirs? A lawyer friend put it best, "Yes. You can require a legal agreement. But who has the money to go to court?" And that's a good point. If you feel nervous at all, a consignment agreement will certainly show a gallery that you are responsible and organized, and you expect the same from them. I'm always happy to sign a reasonable consignment agreement, but a thorough and clear email communication, outlining expectations and agreed to by the artist, serves my needs equally well.

- Most galleries do a 50/50 split. If this sounds high to you, consider the cost of running a gallery. There's rent, staffing, insurance, utilities, shipping, credit card fees, taxes, reception costs, maintenance... The list goes on. And then there are always unexpected and emergency expenses. At least initially, you'll be dealing with gallerists who are not getting rich selling art. They're either rich already, have another source of income, or are struggling themselves. The gallery is also exposing your work to their clients and contacts, which is less tangible but has real value. Some exhibitions, such as those at nonprofits and artist run spaces, will take a smaller commission and that's fine. Just be aware that the standard gallery commission is 50%. Don't, no matter what they promise, agree to let a gallery or venue take more.

- Discounts are common practice. A 10% discount is pretty standard and in most cases you'll be expected to share the discount. In other words, a $600 piece may sell for $540 bringing your net down from $300 to $270. 10% doesn't add up to much and it can be critical in securing a sale. Don't be surprised or upset if you get paid for a sale and there was a discount. Many "good" collectors will try to negotiate an even bigger discount because they know you and the gallery want the cachet of being included in their collection. They'll push for 20%, even 25% sometimes. Most galleries have a policy in place as to the maximum discount they'll allow and how much of that the artist shares. You can always ask a gallery about its discount policy beforehand if you're curious. But as a general rule, trust the gallery's judgment and don't be surprised by discounts.
- You should get paid for any sales within thirty days of the end of the show. Sometimes it takes a while for the gallery to collect final payment or the gallery agrees to a payment plan, allowing the buyer a little extra time to pay in order to secure the sale. In those cases, you should get paid within thirty days after the piece has been paid in full. If your piece sells, thank the gallery, even if the buyer was someone you referred to them. Make sure the gallery has your mailing address and ask if they need you to fill out a W9 form so they can file a 1099 at the end of the year. And then leave them be. Do not ask to be paid during the show or immediately after the show closes. The gallery has to take that show down, follow up with buyers who may or may not have paid in full, and get works wrapped up and picked up or shipped out - all while installing, promoting, preselling and opening the next show. Give the gallery a chance to get through the turnover. Most galleries will pay you two to four weeks after a show closes, once they've had a chance to catch their breath. Some will take significantly

longer. If you haven't received payment 45 days after the close of the show, or 15 days after the timetable they gave you, send a polite email inquiring. That will usually do the trick. If it doesn't, there may be a problem. Follow up diligently until you get paid but try to do it without losing your cool.

- Depending on how much storage they have, some galleries will want to hold onto works for three to six months after the close of a show. It's not uncommon for a collector to contact the gallery weeks or even months later asking about a piece. I once sold a painting a year later. Also, once the next show is up, most galleries will circle back around and reach out to collectors who expressed interest but didn't come through. It's in your best interest to leave works on consignment for a reasonable amount of time if the gallery asks.

Studio Sales

If you are showing regularly with, or represented by, a gallery ask how they feel about you selling work directly from the studio and make sure everyone is in agreement. If you are not represented by a gallery but a collector finds you through a show you've been included in, you should contact the gallery they found you through to discuss. You don't want the gallery to find out and feel like you were trying to cut them out of a sale. This may seem like overkill but there is no better way to build good will with a gallery than to communicate and keep everything on the up and up.

If there are no conflicts, sales via studio visits, open studios, studio parties and inquiries from your website are fantastic. You get to interact with people who appreciate your work and keep 100% of the sale. Without the buffer of a gallery, you are solely responsible for making sure the sale runs smoothly. Here are a few suggestions:

- Be professional. Make sure the buyer gets a receipt, the work is

- packed well and if it's been shipped, you add insurance and get tracking information.
- Make sure you get paid before any work leaves the studio. Cash is best, of course. Checks are fine, but they can bounce or be cancelled. So unless you know the buyer well, make sure a check clears before you release anything. And if there's any chance anyone will ever buy something from you directly, set yourself up now with credit card processing via the Square, PayPal, your bank or any other system. You'll pay a fee for processing credit cards but it's worth the convenience, protection and peace of mind.
- Your work must be consistently priced everywhere it is shown or offered. Imagine how a collector would feel if they bought a piece at a gallery for $500 then showed up at your open studios and a comparable piece was selling for $300. The collector would be upset with you and the gallery. You can always negotiate a very good discount. In fact, most people will ask for a discount when buying directly from the studio. But you have to officially price the comparable piece at $500 to start.

Commissions

A commission is artwork you create specifically for a client at their request. For instance, maybe someone saw a piece they loved and would like something similar in a larger size. Some artists just don't do commissions and that's perfectly fine. If a client finds you through a gallery, curator or designer, the commission should go through that person. Many galleries and dealers will take a smaller cut on a commission since they didn't have to dedicate wall space to exhibiting the piece. If the buyer found you directly, and you want to handle it yourself, I recommend drafting a simple agreement. Clarify all of the details of the commission with the client and then provide them with a document to sign and return. This makes it feel official and will help

clear up any confusion before you start working on the piece. The agreement should include the following:

- Describe the piece the best you can. List the size, medium, any details you've discussed, and the price. Include any additional details, costs and responsibilities beyond the artwork itself like framing, shipping and/or delivery. Indicate the final, total amount the client will be paying.
- Clearly state the payment terms. You should require a 30-50% deposit before you begin working on the piece. The balance is due when the commission is finished.
- Will you be providing the client with a preliminary sketch to approve before you start? Does the client expect to see progress along the way? I think the less a client sees of a work in progress, the better, but some will insist. Be sure everyone is clear about what the client will see, and when, and include details in the agreement.
- Set a "completed by" deadline you know you can meet. Consider padding the deadline a few weeks. Better to finish early than leave the client waiting.
- Make sure everyone is clear what happens if the client doesn't like the final piece. The most common arrangement is that they forfeit their deposit and you keep the piece, which isn't great for anyone. They lose money and you're stuck with a very specific piece to sell. Hopefully, with proper communication, that won't happen.
- If all of this sounds too daunting and you know a gallery you can ask to manage the commission, just ask. They'll probably be very happy to handle it for you.

Chapter Sixteen
Pricing Your Work

Now that you have an idea what to expect from sales, you need to price your work. Without a doubt, the biggest mistake emerging artists make is setting their prices too high. I know your work is incredibly valuable and precious to you. But in the brutal light of commercialism, it is only worth what someone will pay for it and holding onto it doesn't help you. The absolute best place for your work is out in the world, in people's homes and offices where new people can see it and take an interest. You want to sell your work, even if it's for less than you'd like initially, to get it out there. So price your work to sell. Several guidelines to keep in mind are:
- Always price your work the absolute lowest you're willing to sell it for and not be utterly heartbroken if someone buys it. I'm kind of joking, but not really. A few years from now, the piece you just finished that you think is the best you've ever made and you can't imagine parting with for less than ten thousand dollars, simply won't hold the same power. You'll have made more work that's even better. You'll be annoyed that old piece is taking up room in the studio. Have confidence in your future and creativity. Let go of your work, get it out there and let it work for you.
- The amount of time a piece took to complete cannot be

considered. A collector is buying a finished work of art not paying you for the time you spent creating the piece. Simply put, if you want to get paid by the hour to paint, paint houses.

- The cost of your materials doesn't matter. This is particularly terrible news for sculptors, I know. But keep it in mind. You have chosen your medium and while work in a particular medium may skew higher than another, you have to remain consistent within your own body of work. If you decide to add gold leaf to a piece and spend $1,000 on materials, that's your decision. You can't charge an extra $2,000 for the piece to cover your costs.

- The cost of framing doesn't matter unless you discuss it with the gallery first. Some galleries are willing to price a piece and then add framing. As an example, if a piece is $500 and the frame cost you $100, they'll agree to price the piece at $600. If the piece sells you get $350 (50% of the sale price + $100 reimbursement for the frame cost). I don't recommend asking a gallery to do that until you have a good relationship with them. I do recommend being extremely careful what you spend on framing. Many collectors reframe work to suit their tastes. It can be a waste of money to splurge on an expensive frame you love.

- You can raise your prices over time but you shouldn't lower them. Be wary of market forces. A lot of artists I know raised their prices by double, even triple, during the art boom of the mid 2000's when it seemed like everything was selling and the market would never correct itself. Most did so at the urging of their gallerists. When the market crashed a few years later, many of those artists were screwed. Their work was simply too expensive. People weren't buying the way they had been and loyal collectors who supported them early on couldn't afford the drastically higher prices. The saddest part is, the galleries that got greedy and gave them bad advice in the first place could just start fresh with new,

less expensive artists. Listen to advice about pricing but remember it's your work and ultimately your decision. You're much better off starting low and slowly increasing your prices as demand allows. You'll continue to engage your current collector base while new collectors find you.

- If everything you make is selling consistently, consider a 10-20% increase in prices. For instance, if your work is priced in the $500-$2500 range and everything is selling, I'd maybe go up to $550 or $600 - $2800 or $3000. It's a small enough jump that people who missed out at the last show but are aware of your prices can still buy, but enough of an increase to move things in the right direction. The best time to raise your prices, if possible, is before a solo show when there's buzz and plenty of exciting new work available.

- Remember, your prices must remain consistent no matter where they sell. You shouldn't sell work for half price out of the studio or less in an exhibition where your cut is bigger. You can give a special discount out of the studio, but listed prices should remain consistent.

So now you're saying to yourself... OK, this all makes sense. But I still don't know what prices to assign to my work. Keeping everything I've already shared in mind, look around you and try applying the guidelines below:

- Go to some group shows and check out the prices of artists working in a similar medium who you feel are at your level. Ask artist friends for input. You don't want to get caught up in comparing your prices to others moving forward but if you're just getting started looking around at other artists at your level can be helpful. Keep in mind that different types of work will be priced differently. Don't use a photographer friend as reference if you're a painter. One of a kind works are priced differently than editions.

Paintings are usually more expensive than works on paper. If you're still uncertain and are accepted into a group show, ask the curator or gallery for advice on pricing. They will know what other prices are like in the show.

- If you are working in a two-dimensional medium, you might find the "per linear inch" method helpful. If you work in a very large range of sizes, the formula can get skewed for very small (too expensive) and very large (too cheap) work. In those cases, you'll need to make adjustments accordingly. The math for the linear inch system is height + width x per linear inch price = retail price. So an artist with a $25 per linear inch price would price a 20" x 20" painting at $1,000 (20 + 20 = 40 x $25 = $1,000). The best way for an artist to determine his or her linear inch price is to come up with a price he or she feels comfortable with for a few pieces and then work backwards from there. Let's say John has a 20" x 14" painting he'd like to price around $400. The math formula to determine the linear inch price would be $400 divided by 34 (the total linear inches) = $11.76 per linear inch. John also has a 30" x 40" painting (70 linear inches) he'd feel comfortable pricing at $1,000. Divide $1,000 by 70 and you get a linear inch price of $14.29. If John's per linear inch price is somewhere between $11.76 and $14.29, I would suggest he go with $13 per linear inch. That would make a 20" x 20" painting by John $520 (20 + 20 = 40 x $13). He'd then round that down to a nice even $500, just because it sounds better. A 40" x 40" painting would be $1,040, so he'd probably go with $1,000 and so on. Once John's work is selling consistently at those prices, he can consider raising them 10-20%, which would be around $1.50 - $2.50 per linear inch. A student recently pushed me to come up with a per linear inch price I think appropriate for an artist who's just starting out. It depends quite a bit on what the medium is and the types and

locations of the venues where he or she is showing. I'd say somewhere between $5 and $25 is a good price to consider. If you do decide to use the linear inch method, take all of the factors I've mentioned into account. Hopefully you can determine a number that makes sense for you.

- For those of you who have already been exhibiting publicly and people have seen your prices, you don't have much wiggle room to adjust. If you haven't sold anything or have sold a few pieces at prices you now realize might have been too high, be careful. You don't want to alienate anyone who is excited about your career. Consider adjusting your prices 10% down, small enough that it isn't too noticeable, and wait a long time to raise them. If you're still in school, or recently graduated, have only shown in school exhibitions, haven't sold anything yet, and think your prices might be too high, you can definitely reset your prices before you start exhibiting more publicly. Now is your chance to do that.
- And of course, always follow your gut when pricing. If someone suggests a price that you feel is too high or lower than you can bear, listen to their reasoning. But when it comes down to the wire, it's your work and your decision.

Part Six: *More About Money*

Chapter Seventeen
Other Ways to Make Money

Unless you get very lucky with art sales early on (and even if you do, sales fluctuate), you will need to supplement your income. As a dealer, I'm most familiar with the ins and outs of art sales. But as someone with a lot of artist friends, I can offer some suggestions and feedback about other ways to make money such as selling merchandise, the use of your images, and freelance jobs, and observations regarding part-time and full-time work. And if you have an idea for a specific project but don't have the resources to execute it, resources like grants, residencies and/or crowd funding can be helpful.

Reproduction Rights

As your career develops, people or companies may contact you asking for permission to use your imagery on anything from a book cover to a band poster to a shower curtain. If you are comfortable with how your work will be used, this can be an interesting way to make some extra money and gain exposure. Just be careful what you agree to and what you sign. Make sure you understand exactly how your work will be used, and that you are agreeing to the use of your imagery only for that purpose. I highly recommend having a lawyer review any agreement you consider. Being approached in this way probably won't

happen right away, if ever, but it's something to be aware of.

Merchandise

Whether or not anyone ever contacts you about reproducing your work, it's something you can do yourself now. Merchandise isn't appropriate for all artists. But more and more artists are creating and selling merchandise with excellent results. There are different types of merchandise you can sell and different ways to sell it. If you think merchandise might be a good idea for you, take some time to think it through.

Are you organized? Do you have good follow through? Have you built a strong social media presence? If so, you might want to research, produce and sell your own merchandise. You will have to pay to get everything made, and get the word out yourself, but you keep all of the profits. I recommend starting with just one or two items at first. Digital, often called giclée (pronounced zhee-KLAY) prints can be a great place to start. They can be produced somewhat affordably, and as long as they aren't too big, are pretty easy to store and ship. The best way to find a good, reliable printer is through recommendation. Ask any teachers, friends or acquaintances who are selling prints who they use. If you don't know anyone, research online. I suggest trying to find someone local so you can view samples and proof your prints in person. If that's not possible, the printer can send you samples and proofs via the mail. (Snail mail, not email. You want to see them actually printed.) Most printers will take care of scanning your original artwork for a fee. Some will even "print on demand," meaning they'll print in small batches as you sell them, so you don't have to pay for the entire run at once. Just make sure you understand what they will and won't do, how much it's going to cost you and how they handle proofing. You want to make sure you will be able to see proofs until you are happy with the result before you order or offer the prints. Consider making a print of one or two of your best, most sellable images to start.

When it comes to selling your prints yourself, I'm not a fan of big sites like Etsy simply because there are so many artists and vendors selling so many items. Unless you are making something so specific that a stranger can find you easily through a big site's search, it's hard to stand out. If you can find a popular small, boutique site, that might make sense. But in my opinion, with the ease and affordability of eCommerce solutions like Big Cartel, you might as well just sell the merchandise directly from your website. However you decide to do it, you are going to have to drive sales and eyeballs to your merchandise yourself. Let your friends and network know the prints are available. Offer discount codes or pre-sale price breaks, anything to generate excitement. Reach out to local shops and offer to give them a few on consignment. You'll make less money on each print but they'll be hanging in a store. Prints can also be great for charity shows and fundraisers. You can donate a print outright without losing any time and for very little expense. You can also use merchandise for gifts and trades.

If the prints go well, consider what other items you might want to make and sell - t-shirts, jewelry, toys, notecards, housewares, phone cases. Just make sure the merchandise is appropriate for your artwork and goals. If selling merchandise goes so well you don't have the time or room to fulfill orders, you can always find someone to handle it for you and pay them an hourly fee or percentage.

If you'd rather not deal with producing and fulfilling merchandise yourself, there are websites that specialize in selling products featuring artists' images or designs. They range from large stores like Society6 which allows you to upload your art for use on a wide range of products to limited time, curated sites like Cotton Bureau where anyone can submit a design for possible reproduction on t-shirts and hoodies, but only some are accepted. Search and ask around to see which sites appeal to you and are recommended. If you are considering working with any

site that will be reproducing your art for merchandise, you should:
- Make sure your rights are protected and you are only granting use for the purposes you intend.
- Order one of each product you are considering having made so you can check the quality and experience the sales process from a consumer standpoint.
- Reach out to anyone you know (check your online friends or make a new one) who has worked with the site and ask how their experience has been.
- Make sure you understand, and are comfortable with, how the company handles pricing, royalties and payment.
- If you decide to move forward, don't rely on the site for sales and promotion. Share information about where to find your merchandise as much as you would if you were selling the products on your own website.
- And if you do work with one of these companies, keep copies of all correspondence including sales reports, payment records and agreements. You want to be protected in case anything goes wrong.

However you decide to handle it, if (and only if) merchandise is in keeping with your goals, it's one way to supplement your income and promote your work.

Freelance Work, Part-Time & Full-Time Jobs

There is absolutely nothing wrong with working full time, part time or freelance. It does not make you any less of an artist. It makes you a grown up and helps pay the bills. I know successful fine artists who are also teachers, art directors, designers, illustrators, storyboard artists, set decorators, programmers, receptionists, book keepers, baristas, waiters and bartenders. I even know an artist who's a surgeon. The key, whatever your situation and financial needs, is to also make time for the

studio. And if you can, try to do something that compliments your goals and personality. If you feel inspired being around other artists and being creative, even if you aren't working on your own art, take that to heart. Consider freelancing in any way that utilizes your artistic talents. Learn a program or skill that's in demand and then connect with an agency that helps freelancers find work. If you want to meet and be around other artists, look for jobs that attract artists. I know several who work as art handlers. It's hard work but the pay is decent and if you're anxious to understand how galleries work, see successful artists' studios, and work surrounded by other artists, art handling might be a good fit. If you find using your artistic skills outside of your studio practice draining, look for something that doesn't tax your creativity. And as with everything else, don't wait around. Of course, search job listings. But what are you good at? What do the people around you need help with? What does your community need? Could you charge a per student fee to teach an art class at a local bar? How about life drawing out of your studio? You provide the model and space for a fee? And if you're lucky enough to have a full-time job that allows you time to get into the studio, think twice before leaving. As your career takes off, try to juggle your time and save money. See if they'll let you cut back hours rather than leave entirely. If you plan carefully for your eventual departure, you'll be in a much better position than if you quit prematurely.

Grants

Many artists are intimidated by grants. It takes a lot of time and energy to search for appropriate grants and apply. And what, really, are your chances of being selected? Honestly, it depends. There are almost as many types of grants as there are artists. Some applications are more difficult than others, and the awards range from nominal to life changing. But anyone who's been a recipient will tell you that overlooking grants is a huge mistake.

The first and most important thing to look at when considering applying for a grant is whether or not you even qualify. Many grants require some or significant exhibition history. Others are geared towards emerging artists or simply want to hear about a specific project. Read through the materials and determine if you are a potential match. If you are, apply. It's great practice articulating your needs and your vision. As with submitting to exhibitions and galleries, always follow instructions precisely, meet all deadlines, proofread, spell check and double check. If the grant is not for a distinct project, but asks you to identify a need, be specific, creative and engaging. Don't just say you need to buy food and pay your rent. Outline how you'll use the money to create a fantastic, relevant body of work or better communicate your vision. If the grant is for a specific project, get as detailed as you possibly can. Many grants will require a budget. Don't just guess and throw something together. Do your research and be thorough. And finally, don't give up. Selection committees change. Some years are more competitive than others. Some ideas are better than others. Keep applying.

When it comes to artist resources, there are probably more books, websites and articles dedicated to pursuing grants than any other subject. You'll find a few dedicated solely to grants on the resource list at the end of this book. Also, many of the same websites and lists that provide information about juried exhibitions list grants. And your local arts council should be able to provide you with information about grants specific to your region.

Residencies

When you participate in a residency you go someplace for anything from a very short to a very long period of time to make art in a somewhat organized environment surrounded by other people also making art. What could be better, right? A residency can provide you with the space, access, resources and time to realize a specific project or

it can just be an amazing chance to create new work, meet other artists, gain perspective and get feedback. There are many different kinds of residencies. They can be fully or partially subsidized. Locations may be urban or rural, accommodations private or shared, food provided or not. Some allow you to bring your spouse or partner or pet. You always have to apply, most expect you to do some sort of presentation as part of the residency and they all expect you to arrive with a good attitude, open mind and sense of adventure. From what I hear from the many artists I know who have participated in residencies, it sometimes turns out different than you'd expected, but it's always a learning experience. If you are in a situation that allows you to get away for any length of time, I urge you to look into residencies. And of course take the application process just as seriously as you would any other opportunity.

Crowdfunding

With the rise in the popularity of crowd funding sites like Kickstarter and GoFundMe, I've also noticed a rise in the misuse of crowd funding by artists. For example I was invited by an artist to contribute to his campaign to raise money so he could frame the works for his upcoming show. I found that off-putting. I noticed he didn't make his goal so I assume others did too. If you're an artist, covering the day-to-day costs of being an artist is your responsibility. You can't ask for help with that. However, if you are trying to finance a special project, particularly one with social value, you should definitely consider crowdfunding. I know an artist who used crowdfunding to raise money to travel to, document, and create a body of work about, a well-regarded wildlife sanctuary. Her gallery agreed to show the finished body of work and a portion of all sales from paintings and prints will be donated back to the sanctuary. Her paintings sell for a good amount of money and the gallery is well respected so there's real potential to raise money and awareness. Sure, the artist probably really wanted to visit the sanctuary. But I'm an

animal lover and fan of the artist's work. I was happy to contribute a few dollars to help fund a project with obviously good intentions and the potential to raise money for a worthwhile cause.

Chapter Eighteen
Budgeting, Taxes & Trades

Managing money can be difficult for anyone who finds the subject daunting, frightening or just plain boring. I didn't start a personal budget until I opened my gallery and had to manage the finances of the business. Money was tight and I really needed to know the bare minimum I was going to have to pay myself. In the last section of this book I asked 40+ artists and arts professionals for one piece of advice each. This would be mine:

Even if it terrifies you, create a budget of what you must earn each month to meet your basic needs and what you'd like to earn to have a decent life. I really wish I'd started that practice earlier in my life. Keeping a personal budget changed my relationship with money drastically. I wasn't clueless and terrified all the time. I was informed and terrified most of the time. But least I knew exactly how short I was going to be and could proactively look for ways to problem solve. I hosted speed dating events and took freelance writing gigs during the lean times and was happy to do it to support my goals.

Your basic budget doesn't have to be fancy. It can be a word document or a slip of paper in a drawer. I like to keep an excel spreadsheet I can tweak every month when my expenses fluctuate. Once you have a clear idea of what it is you really need to earn to survive, you

can look for productive ways to supplement your income and also make smart decisions as they relate to your goals. Maybe you really want to take a trip to explore New York galleries because that supports your goal to understand the art landscape, and eventually exhibit, in New York. You have a cousin you can stay with for free. You just need to come up with the bus, train or plane ticket and spending money. Every time you meet your monthly minimum goal, you can set anything above that aside for your trip. As far as the second budget goes, consider that a goal to meet and exceed more and more frequently over time.

Don't forget a line item for taxes in your budget. Knowing what you'll need to pay can be tough when you have no idea how much you are going to make. But chances are, some or all of your income is not being taxed. You will receive one or more 1099s next January. Those forms will also go to the government and the government will want its cut. And don't forget, it isn't just freelance or contract work, most galleries file 1099s for their artists. Come tax time you will have to pay taxes on any art sales you made the previous year. You need to plan accordingly.

One thing you can do immediately is start saving your receipts. Depending on how your year goes, a lot items will be deductible - supplies, studio rent (or part of your personal rent if you work at home), travel, all sorts of things you might not think about. Save everything. And this is one area where I do not recommend you do it yourself. You will almost certainly save more money in taxes going to a professional than you will spend paying them, and you'll avoid mistakes. If you have an accountant you like already, great. If not, find someone who has experience working with artists. Ask that accountant approximately how much he or she recommends you set aside from each check for taxes. They may suggest you pay quarterly which means four times a year you send the government what you've set aside. This can be a good idea if you find saving and holding onto money difficult. Regardless of what

your accountant recommends, get one, ask, and follow their recommendations. Your earnings will undoubtedly vary each year but having a basic plan in place will help avoid any devastatingly expensive surprises.

It goes without saying that saving money, if at all possible, is a good idea. Even if you are wildly successful, you'll be happy to have money set aside down the line. It's also worth mentioning that another, although much less direct or reliable way to try to create a nest egg, can be building a valuable art collection. Artwork that is selling for $200 to $2000 now could end up worth tens, even hundreds, of thousands down the line. And you don't have to buy the work. Trading art is not only a great way to get your own work out in the world, it's also an opportunity to build a personal art collection that will bring you happiness for years and just might end up being worth something someday. If there's someone at or around your level, who seems to genuinely enjoy your work, ask if they'd like to trade. Consider hosting an annual holiday gift exchange with other artists or an art swap party with studio mates. And don't forget to hold on to a piece of your own work now and then. You may never want or need to sell anything from your personal collection. But it's nice to have the possibility of some added security in the future.

Part Seven: *What Do Other People Say?*

Chapter Nineteen
Advice from Artists & Dealers

I was preparing a syllabus for a Professional Practices course and curious if there was anything I'd left out. I posted on Facebook asking my artist friends "What's one thing you know now that you wish you'd learned sooner?" Several people posted thoughtful, sincere responses, each from their own experience and perspective. So when it came time to write this book, I thought it would be helpful and interesting to include some additional perspective. I reached out to over 50 friends, colleagues and acquaintances and asked what one piece of advice they would give to any emerging artist. I was surprised and pleased by how many people agreed to participate, which is proof that artists and arts professionals are generally generous, helpful and community-minded.

Some contributors addressed issues of creativity and inspiration that I, since I'm not a visual artist, could never offer you. Some reinforce the opinions I've expressed in this book. A few disagree with what I've said. But that's the art business. With so few hard rules, you'll often be put in a position of simply having to use your best judgment. I hope you'll take all of the advice in this section to heart as every contributor put thought and time into sharing something they believed you might find helpful. What follows is that advice, in all shapes and sizes, from working artists and experienced art dealers.

Kirsten Anderson, *Art Dealer*
Seattle, WA
Founder/Owner, Roq la Rue

My advice is when you decide it's time to approach a gallery, check to see what their submission policy is. It's a good idea to honor it if the gallery says they do not accept submissions. If you submit anyway you are essentially demanding a gallery pay attention to you when they are in no position to offer help, which is rude. You also set yourself up for totally unnecessary rejection, which is no fun for anyone. If they do take submissions, be polite, be brief, include a link to your website with current work. Don't say, "My art is perfect for your gallery" - I've heard that literally hundreds of times and they have never been correct. Don't take rejection personally, even though that is hard and takes practice. Your art may be great, just not for that gallery's audience! I also think it's important to distinguish between art making and the "art world". They are linked, but two completely different things.

Noah Antieau, *Art Dealer*
New Orleans, LA and San Francisco, CA
Consultant and Founder/Co-Owner, Red Truck Gallery

It's not going to be a straight line from where you are now to where you want to be. But along the way to your first $50,000 canvas, consider yourself lucky when the rent gets paid from doing anything creative. Don't be one of those cliché art school kids who considers himself above the idea of art as commodity. Take the commercial work. Take the design work. Do the band's poster design for $20 and a six-pack. Do your best friend's sister's wedding invitation. Do whatever it takes to be able to call yourself a working artist. It's a noble title, regardless of the particulars.

Rick Araluce, *Artist*
Seattle, WA

I used to be one of those people who thought he'd never get a grant. I had tried once and hadn't got one. So, therefore, I would NEVER get one. That was my mental state: Loser. Several years later, I tried again. This time I spent time with the thing, worked on it for weeks and weeks, polished it to a gleaming diamond. Every period and comma, I went over and over again. And, lo and behold, I was funded! I had become one of those people. The ones who received grants.

Just recently, I was named a Fellow of the John Simon Guggenheim Memorial Fund. That's right, I'm a Guggenheim Fellow. I had applied four times before. I did not quit. The fifth time was the charm. Every time I make out a grant or project funding application, I swing for the fences. You should too. Don't be lazy. Don't feel entitled. Be compelling. Be concise. Convince them why they should give you money. It's WORK. Treat it like work.

Now, get busy.

Carrie Ann Baade, *Artist*

Tallahassee, FL

Associate Professor, Dept. of Art, College of Fine Arts, Florida State University

Monet at age 28 attempted suicide by jumping into the Seine. When he didn't die, he swam back to shore regained his clothes and painting pack and carried on. Let's be honest, it is easier not to paint. But if this is who you are, then paint you must and you will need to be more savvy than Prometheus to make the work and make a living. There will be ups and downs. I was once reading about the great printmaker M.C. Escher. The only year he achieved financial success was 1929. I looked into other artists' records, and the boom before the crash gave many artists their luck. When the market was gone, they suffered like everyone. In reading the biography of Peggy Guggenheim, I learned that artists who are now worth millions were given maybe a thousand odd dollars for their works while they were alive... all the real money is on the secondary market. For me this is an endurance race - a long distance run, it is about the whole life of making art. I have worked doing commissions, teaching, curating, in order to paint another day. Everything goes back into the luxury to paint and live this extraordinary existence of an artist. Delacroix said in his journals, "If you are not skillful enough to sketch a man jumping out of a window in the time it takes him to fall from the fourth story to the ground, you will never be able to produce great works." This urgency to create must be in your blood. This is what no school and no one person can teach you.

William Baczek, *Art Dealer*
Northampton, MA
Owner/Director, William Baczek Fine Arts

I have a theory that the best art ever made is in a shy person's basement.

There's a reason why some artists are successful and others aren't. When I'm talking with younger artists I stress that making, exhibiting and selling art in a commercial gallery is just like any other job one hopes to be successful at. It means working hard, honoring deadlines and trusting your co-workers to do their jobs well too.

A gallery might not be actively seeking new artists, but they will rarely ignore someone who makes excellent art and approaches them in a friendly and professional way. An email with a link to a well-designed and easily navigated web page is helpful. Know that gallery's program and mention why you would fit in well. Creating the art is only a part of it (albeit a very important part). Have it photographed and framed professionally and post it online promptly. A relationship with an art gallery is just like any other relationship. Whether it is personal or professional, it involves trust. When an artist asks me "how much commission do you take?" I won't work with that artist. It immediately shows a hint of distrust and misunderstanding of the work that a gallery should do. We don't "take" or "give" a commission - we share it. The artist does their work (making the art, photographing it, etc.) and the gallery does their work (displaying it, contacting clients, press, art fairs, etc.). And like all relationships, sometimes they end. Two very nice people can get divorced and they are still very nice people, they just no longer belong together. But when it works well, there's nothing more amazing than two people doing their jobs to the best of their ability and trusting their other half to do the same.

Ali Banisadr, *Artist*
Brooklyn, NY

I have been making art as long as I can remember. When I was a child living in Iran through the chaos of war, I would create art to try to make sense of the world around me. The worlds I would create were a safe place for me to organize my thoughts and to express my vision.

Even though later on in life I went to art school and was taught about art as a career I have never forgotten that the most important part of being an artist is to stay true to your own vision and never let anything change it.

Rebekah Bogard, *Artist*

Reno, NV

Associate Professor, University of Nevada, Reno

 Create a mailing list. Begin with people who have purchased your work or express interest in it. As you build your list, pay attention to gallery advertisements in magazines that resonate with you and include them. Do not forget to include museums you aspire to exhibit in. Also include editors of books and magazines, curators, art critics, gallery directors, and others who inspire you. When you have a show, make postcards with an image of your work, exhibition and website information. Send them to your mailing list. Yes, mail them out, with stamps! Postcards make a far greater impression these days than Instagram, Twitter, and Facebook as they are physical, don't disappear and aren't forgotten in a matter of moments. Make sure to order plenty so that you have leftovers. I always take my leftovers to art conferences (such as NCECA or CAA) and leave them on tables. You never know who will pick them up and post them in their studio or classroom. I have received major gallery exhibitions from this practice, as well as visiting artist gigs. If you want to be proactive, you can mail out leftover postcards to Universities with a sticker on it saying that you are interested in exhibiting in their gallery or being a visiting artist.

Benjamin Britton, *Artist*
Athens, GA
Assistant Professor, Lamar Dodd School of Art, University of Georgia

I got a great lesson from teachers who were serious artists as well as kind and generous people. No matter what you achieve, try your best to be compassionate to other people and their struggles. As artists, we are making, looking, and showing; we take positions and give and take criticism. This is profoundly exciting but also stressful. Being compassionate with people and having a sense of humor even when you want something really bad makes things less awkward. Also, it takes a little perspective to realize how remarkable the position you've taken to be an artist is. I wish I'd appreciated how crazy special the scene really was where I found my footing as a young artist. The lesson that you and your friends are making culture from the very beginning, and making it the very best kind of scene by supporting and challenging each other, is super important. Maintain contact with your allies. Some of the things you get into first are the things that hold unfiltered fascination, even after time and distance reveal the context and philosophical reasons for why those things are engaging.

Making art is a way of moving through life with a different perspective, and is inherently charged with a position of resistance to the mainstream. It's going to be an adventure, so you'll need help. You'll need to be resourceful, thrifty, and brave, but looking back on your life you probably won't regret also being kind and having a sense of humor.

Mia Brownell, *Artist*
New Rochelle, New York
Professor of Art, Southern Connecticut State University

Keep pace with the evolution of your imagination! The most rewarding aspect of being an artist has been bridging the gap between the unseen idea in the mind and its manifestation into an actual object. I am always trying to find new ways to remind myself that a world of limitless solutions exists, and at the same time, discover my limitations - both conceptual and physical. Through the discovery of limits and boundaries I can begin to understand the universal concept of freedom, chance and experience. Experimentation has been the way to discovering personal solutions and dialogue has been a crucial part of my process. This dialogue is a bridge to your imagination, and can start between you, your practice, other people, places, things, and just about any idea or event past or present that excites you.

Charles Clary, *Artist*

Conway, SC

Foundations Coordinator, Coastal Carolina University

 Understand, while it's difficult to fail, it is far more difficult to succeed and be prepared for that success. It takes perseverance, sacrifice, hard work, and patience to succeed in life no matter your discipline, and the art world is no different. While it's true that luck can be a factor in your success, you create that luck through working your ass off and always pushing forward no matter how challenging the road gets. So why be a victim of your circumstances when you can be a purveyor of your future?! One of the best pieces of advice I ever received was from my grad school mentor. He said: "Always have enough work for two solo shows and always keep evolving. That way you're prepared for anything that the art world throws at you!"

Peter Drake, *Artist*
New York, NY
Dean of Academic Affairs, New York Academy of Art

At the beginning of my career as an artist I wish that someone had told me not to take things for granted. This may sound obvious, but it's really easy to assume, when there are a lot of good things happening for you, that they will continue forever. You forget how unusual it is to have a gallery or galleries, to get reviews, to be in great group shows and public collections. One of the things that you have to maintain at these moments is a certain humility in the face of good fortune. This allows you to enjoy the unique moment you are in but it also prepares you to maximize each of these remarkable events. If a great collector who is on the board of a major museum asks you to do a portrait of them, you should find a way to maintain that relationship. When you get a review in *The New York Times,* you should make an effort to develop a creative conversation with that critic. If a gallery is really developing your career and getting you into great group shows, you shouldn't assume that all galleries will, or even can, do this. I have seen so many artists leave great galleries in a huff for something inconsequential because they assumed that the good fortune that got them into the gallery in the first place, would follow them forever. Were they surprised.

Cara Enteles, *Artist*

New York, NY

1. Your best connections are your peers. Stay in contact with them. Be curious. Visit other artist's studios and add like-minded people to your mailing list. Galleries often trust their artists to recommend their friends. Let connections happen organically. Most of the galleries I work with saw my work at another venue and contacted me.

2. Find a way to make ends meet as a back up source of income until you get to the point where you can earn a living off your art. As much as possible, I would recommend a job that lets you use your artistic talent in some way. For many years after art school, I worked as a clothing designer. I gradually made this into a permanent freelance position, which allowed me more time to focus on art. Then changed my role into a "creative director" before leaving to pursue an art career full time in 2008.

3. Above all, follow your instincts and take risks.

Roni Feldman, *Artist*
Los Angeles, CA

In 2010, Max Presneill and I established a collective of artists, writers, and curators called Durden & Ray. Many of us were already represented by galleries, but wanted to have more agency and exhibition opportunities, particularly between solo shows. D&R partners with galleries and non-profits in the L.A. area to host exchange shows with like-minded groups in other cities and countries. For example, we send some of our artists to another country to curate a show along with artists there, then they send some of their artists to curate a show with some of us at one of our partner spaces in L.A. We also collaborate on art projects together, create catalogs, and serve as a network of support and information. Everyone brings something to the table and it's completely democratic. Each member has an equal vote in our activities. We have had exhibitions in Tokyo, Japan, Berlin, New York, plus many other places. We also just opened a brick and mortar project space in L.A.'s burgeoning industrial arts district. It takes heaps of work, but D&R provides most members with six to twelve exhibitions per year. And anyone can do this. It just requires a very motivated group of people.

Zach Feuer, *Art Deale*r

Hudson, NY

Co-Owner, Feuer/Mesler Gallery and Retrospective Gallery

- Keep your overhead low.
- Put as much money into an IRA or retirement account as you can (Start your first year out of school if you can).
- Don't move to a city where you will have to spend all your waking hours just paying the rent.
- Make friends with lots of artists IRL and online.
- If no one will show you or your friends, show yourselves.
- Don't pay to be in juried shows or vanity galleries, and if you have in the past, take them off your resume.
- You don't need business cards.
- You do need a website.
- Remember - if you make it - what comes up, must go down, so be really nice to everyone (Not just fancy art world people, but also your shippers, framers, assistants, etc).
- Don't burn bridges. Stay humble.

Lori Field, *Artist*
New York, NY

My advice is to really hone in on your passion, and your own authentic voice in your art making practice. The way you, as an individual, have of seeing, and realizing what you see in physical form is valid and important to honor. There will be a lot of influence out there to make work that looks like other people's work that is "successful" or on trend, or selling at the moment. Stick to your own vision. Be influenced by and inspired by others but don't replicate what they do. Take it as a kernel of where to begin and expand on it. Make it your own. Remain obsessive and work very hard on what makes your work unique and stand out. Aim to have people recognize your work in a crowded room... to know immediately that it's undeniably yours.

Eric Finzi, *Artist*

Kensington, MD and New York, NY

There are many different ways to get to Rome. Of course there is the main highway, getting your MFA at a few select schools, and settling in Brooklyn.

But what is one to do if, for whatever reason, you can't follow the traditional path of the artist who is trying to solidify their status as a rule breaker? Follow your muse – work on whatever pulls you, whatever motivates you, whatever is so difficult or ridiculous that no one else wants to go there. If there is a fork in the road of your art, choose the more difficult path, the road less traveled. There you will engender an art that truly is unique, something that may last beyond you, if you care about such things. If you work on something truly different, don't expect quick acceptance. Expect rejection, over, and over, and over. The more original your work, the longer you should expect to get rejected. We are, of course, herd animals, and one human's so called rebellion may actually be fitting so well into expected constructs of avant-garde that it is nothing of the sort.

Befriend everyone, and anyone, and be yourself. Befriend artists whose work resonates with you. Exchange work and ideas. Cultivate the social side of yourself, and be generous to others – you never know where it might lead.

Camille Rose Garcia, *Artist*
Los Angeles, CA

If you want to make a business out of your art, learn the art of business. Getting into a gallery will never solve all of your problems, so quit making that the only goal. Don't try to "get into the Art World", make your own art world and invite people in. You can't wait around for people to discover how brilliant you are. If you want to make time for your art, you have to pencil it in or it will never get done. You have to be selfish. You have to disappoint others. You can't go to every birthday party or wedding people want you to go to. Turn off the phone and put it in another room and work 2 straight hours on your art with no interruptions. Don't worry about "likes". Worry about getting better at your craft, and being able to support it financially. Don't take on a lot of debt. Art School is a scam. Critical Theory is useless in the real world. Learn how to grow things from seeds.

Bert Green, *Art Dealer*

Chicago, IL

Owner, Bert Green Fine Art

My gallery works with artists at every career phase, early, mid-career, and mature. I tend to not take on artists straight out of school, because I want to see if they have what it takes and stick with art making for at least 5 years after graduation without giving up. Once I take someone on, the most important thing I look for in my relationships with artists is professionalism, consistency in studio practice, and reliable communication.

A gallery can provide an enormous amount of support to an artist by handling the tasks that artists generally disdain, such as marketing and PR, pricing, sales tax collection, collection management and placement, etc. In exchange, galleries will expect artists to competently handle the most important thing of all, art making.

The relationship is based on mutual trust and develops over time; most of the artists I work with have been with me for many years. I do not micromanage. But I do expect my artists to respond timely to requests, be available for studio visits when appropriate, and show up to gallery events so as to be available to the community of people that engage with the gallery and are interested in our programming.

In short, the most important things are: be available, be on time, make great work, and communicate clearly. I will handle the rest.

Ken Harman, *Art Dealer*
San Francisco, CA
Owner, Hashimoto Contemporary / Spoke Art

As people begin to rely more and more on social media, not just to keep in touch with friends but also to get news, sell art and self promote, it's important to keep in mind that these channels may not be the best way to connect with your favorite gallery.

In the past few years I've seen an uptick in the number of submissions we receive in Instagram comments and on our Facebook page. While this is undoubtedly one of the easiest ways to get in touch with a gallery, it can also make you look unprofessional and get you started off on the wrong foot.

When submitting to a gallery, do a little bit of research. See if you can find out the gallery director or owner's name, and address your cover letter or email to them directly. Be sure to include a CV (curriculum vitae), a bio, examples of your work and links to your website or portfolio.

Most importantly, be sure that the galleries you're submitting to are a good fit! Try to target galleries that exhibit works of a similar aesthetic to your own, and see if your price points are in the ballpark of the works they're selling.

If the gallery is local, try to attend as many events at that gallery as possible so you can get a good sense of the space and a familiarity with their staff. However, don't submit in person, that's always awkward (for everyone involved!).

Julie Heffernan, *Artist*
Brooklyn, NY
Professor of Fine Art and Director of Painting and Drawing, Montclair State University

Above all, grow your mind. Court your imagination as a lover would; work that mental muscle like an Olympian. This is one way:

Bring a couch into your studio. Lie in it, directly across from your unfinished artwork (not to the side) and gaze at it; let it enter you with no obstacles between you and it (no chairs or even rags on the floor). As you're gazing at the piece notice where your eye stops (that's most likely a problem area) and allow yourself then to drift and imagine other possibilities there. At a point you will move from a conceptual relationship to the work (logical, linear), to a more supple, non-linear relationship, one related to Theta wave states in the brain, where spontaneous images arise. Your mind in that state will manifest particularized imagery related to your work; you aren't forcing ideas out but allowing subconscious connections to well up that will relate on a deeper level to your piece than mere rational conceptualizing can achieve. Seeing pictures in your mind's eye, filling yourself up with myriad possibilities, is the mental workout with your subconscious that will hone your brain into a picture making and problem-solving organ. Don't settle on any one visual solution right away. At a point you might fall asleep, and when you wake up you will very likely know which version of the many imagined possibilities is the right one. This is a glimpse into the larger workings of your creative mind.

Seonna Hong, *Artist*
Los Angeles, CA

There are many things I've learned and continue to learn as a professional artist. In addition to the work itself and finding the right work flow and environment to create it, there are 2 basic tenets that I try to carry with me to every job, every gallery experience, every person I work with, and those are: to be nice and to be on time. There are so many talented artists out there that sometimes the thing it can come down to is if you're a pleasant person to be around and if you can be counted upon.

Oh! And a couple of random things I've learned the hard way: there's a reason why you should use archival materials, and make sure the room is clear of cat hair before you varnish!

Andrew Hosner, *Art Dealer*

Los Angeles, CA

Co-Owner/Curator, Thinkspace Gallery

My advice for young artists stems from an article in *Juxtapoz Magazine* written by artist Michael Sieben. The most important thing you can do is to build your own voice. There are far too many artists out there currently that seem like carbon copies of bigger, more established artists. Sieben spoke about young artists these days sharing their work publicly via social networks much too early and, in turn, getting feedback that may mislead them.

There is nothing wrong with emulating a favorite artist as you build your skill set and hone your chops, but to post it online too early could be a bad thing down the line. Develop your own style and let it shine. Once you're confident something is starting to become your own, then put it out there for feedback and commentary. But the platforms of Instagram and Facebook are no place to get real, worthwhile feedback that can guide your career (or in many cases, misguide if you listen to the minions that don't know a copy when they see one). It's hard to do so, I will be the first to admit this, given how many submissions we see. But when one comes in that checks off the boxes mentioned above, it's a beautiful thing and hard to dismiss.

David Humphrey, *Artist*
New York, NY
Instructor, Columbia University, MFA
Instructor, University of Pennsylvania, MFA

It's good to remember (not when you are making new work as it might be better to forget) that there are armies of manically mono-focused people (I almost said monsters) out there who want something close to what you want. They are your tribe not your enemy.

David Kramer, *Artist*
New York, NY

Alone but never lonely...

I remember being a student back in Brooklyn in the 1980's. I was broke and living in a shitty neighborhood. I was going to Pratt Institute where they gave me a studio in the sculpture department and I had a key to the building and could come and go as I wished. I loved waking up at the crack of dawn and getting to the studio to work while no one was there. This was my very first studio and I was making sculptures using all kinds of found building materials from steel to brick to wooden beams torn out from crumbling brownstones in Bed-Stuy. But what I remember most was walking home from the studio late at night (sometimes on Friday and Saturday nights), too poor and often too exhausted to go to a bar to have a drink and meet up with friends. I remember looking up at the dark streets ahead of me as I walked home and telling myself, "...this is it! The exciting life of a New York City Artist!" Just like I pictured it!

I would go home and make some food and pass out, and then get up at the crack of dawn and start the whole process all over again.

Which gets me to my real advice for artists... You better enjoy being alone.

Looking back now as I write, it is clear to me that not much has changed. Sure I have had a ton of shows and at times made some actual money off of my work. But in the end I always come back to finding myself alone in my studio or alone on my way to my studio or alone on my way home. Being an artist is a lonely business. But I don't mind. I love what I am doing. And most of the time I don't even realize that I am alone.

Martin Kruck, *Artist*
New Rochelle, NY
Professor of Art, NJCU

The advice I tend to give most often to my students involves how to think objectively, distance themselves as it were, from their artwork. The focal point for this is the artist statement but quickly expands to how to reference and reflect upon their art making or design practices as well. Young artists tend to only consider how they made their artwork or how well they followed the guidelines or the words of those who may have guided them. While useful to acknowledge, this does not fully contribute to validating an artistic practice or its products. Gaining perspective by observing your practice amongst a field of others, and the culture and time in which it is done, is a career goal that follows a wide arc. It is a very useful skill when applying for grants or project funding, employment in the field, or self-promotion when engaging sales or working with professional clients, galleries, or patrons. It is not the sole responsibility of your art dealer, for example, to place your work in cultural context, nor should you allow this without your input. In the same way as stepping back from your artwork helps to review and adjust the composition or proportions, understanding the cultural context of your work is one thing that will assist in sustaining an artistic practice, or allow it to evolve.

Secondary advice: When starting out, use your money to buy the tools you need to do the job, then use the job money to buy better tools to get a better paying project. Continue in this way until you are established; you will know what to do then.

Allegra LaViola, *Art Dealer*
New York, NY
Owner/Director, Sargent's Daughters

My advice to artists is to be honest and upfront with your dealer. If you want something (sales, shows, press, etc.) you need to tell them. You are a team pulling together for the same common goal: to have the best possible exhibitions and career for the artist. A relationship is a two-way street and nobody is a mind reader. If you feel like you want something and are not getting it - just ask. Remember that your dealer is working hard for you and wants the best outcome for your career - demanding and asking are different things! Be open about your needs and thoughts and your dealer will do her best to make sure these are a top priority.

Travis Louie, *Artist*
New York, NY
Instructor, School of Visual Arts

Obviously always read through any contract that anyone sends you to sign. There are grifters out there who use them as tools to trick people into accepting terms that are unreasonable and or just plain criminal. That, of course, is an extreme that is usually not the norm. Things about contracts that artists always seem to forget:

1. They are generally negotiable.

2. You also have to consider that usually it favors the party that draws up the contract in the first place. So it's expected for you to read it over.

3. You never actually have to sign any contract from anyone. Not only is it not a deal breaker, but often, if the gallery wants to work with you, they'll bypass it.

I think of contracts as part of a conversation between the artist and the gallery. Don't ever be afraid to ask others for a second opinion or to tell them you need to think about it before signing anything. In this day and age with near constant social media and artists being only a mouse click away from everybody in the community, it would be foolish for either party to pull a fast one. Reputations can be ruined in a blink (not that you can't bounce back, but why put yourself in that situation in the first place). An email or letter is good enough for there to be a record of correspondence detailing the specs for an exhibition, timetables, what is expected from either party, or standard procedure. I have read through some ridiculous contracts with things written in them like exclusivity clauses, low percentage rates on print runs (some gallery wanted to pay me 10%), rights that no one should ever give away. It never ceases to amaze me what people will try to get away with in a contract. Always ask yourself, who is this contract serving? Who does it protect? And from what?

Jayme McLellan, *Art Dealer*
Washington, DC
Director/Founder, Civilian Art Projects

Pricing your art is tricky. There is no perfect formula. You figure out the number – just how much do you need for that piece? Next, figure out what your market will bear – not *the* market, *your* market. If another artist sells a painting for $5,000 this does not mean you will too. Sure, your painting is bigger and better, but your last one of the same size sold for $2,500. Don't raise your prices too fast because once they are up you should not lower them.

And perhaps that artist knows how to woo people and perhaps you sit in your studio and lament that you can't sell while he's out there at art events meeting people, inviting them to his studio, trading paintings with fellow artists to make them like him, and talking loudly about how he's informed by the Moderns, hates AbEX, but really loves material, process and Ellsworth Kelly. What are you doing?

You might not need to do the exact same thing as someone else. Success is a unique personal formula that you must find over time. Figure out what works for you. Most collectors who buy the work of emerging artists do so because they want to become a part of the artist's success. They like to hear about your ideas. If they are creepy, you don't have to be best friends. But most folks are nice and they care. So be nice back and take as much interest in them as they have taken in you. It will pay off. This is one of the foundations for a successful art career.

Marion Peck, *Artist*
Los Angeles, CA

One bit of advice I would give would be to keep a reference file of images that inspire you. This can be so important. You need to find images that spark something in you, and gather them together. Gathering reference materials is so easy and instantaneous now, not like the old days when we had to schlep to the library... unbelievable how time consuming and fruitless it was sometimes! Now there are endless images at your fingertips, but you need to find the ones that awaken your creativity and keep them near to you. Sometimes it can be something blurry and vague... I have this one little scrap of paper with a very low-rez image of a kitten's face on it, and something about it makes me come back to it again and again, trying to capture something elusive about it. When you find an image like that, hold onto it like it was gold.

Martha Rich, *Artist*

Philadelphia, PA

Since I became an artist later in my life after working in corporate America for 15 years, I want you to know you can do this! BUT you have to really want to do this to succeed. I was super motivated because I vowed never to work in a cubicle again. It took me a while, but it was the best thing I have EVER done. EVER I say! Here's my advice:

- Hang out with other motivated artists who are doing what you want to do and learn from them.
- Have a support system of people who will encourage you when you want to quit.
- Don't use credit cards. They are the devil. The less debt you have the more freedom you have.
- Make art every day or close to every day. The more you make the better you get.
- Give yourself projects/challenges to do like: "I will draw 200 bras in one day" or "I will make something only using happy meal toys for a week"
- Be generous, but not in a wimpy way.
- Get a studio with other artists you respect, even if you think you can't afford it.
- Don't fear failure. You are gonna fail. Everyone does, but it really is no big deal unless you quit.
- Make art that is authentic to you. If you try to make art that will "sell," it probably won't.
- Don't be a snob about fine art vs. commercial art. The lines are super blurred these days. Making money from art is a good thing whether it's selling a painting or designing a bag.
- You may have to work at a real job while you are making this happen. DO NOT get a creative job. Get a job you won't get comfortable in. Save all your creative juices for your own art practice!
- Don't quit.

Jen Rogers and **Kerri Stephens,** *Art Dealers*
San Francisco, CA
Co-Owners, Varnish Fine Art

All art careers share common challenges, relying on thick skins, dedication to the work and great advice for success. Just as there are many stages and media formats for an actor to stretch his or her wings, artists enjoy numerous ways to make a life in art. It can be a tough gig, but applying yourself creatively leads to rewards. Many artists must supplement their income beyond the sales of artwork in its purest, most uncompromising form, so choose side jobs that allow you to sharpen your skills and hone your craft. Just like musicians, artists need savvy business managers to connect them with the right audience. The connective tissue between artists and collectors is broader than ever and includes innovative art dealers working in new ways. We've found that artists of every level seek help from art dealers throughout their careers. When you and your artwork are ready, partner with a professional who shares your core values and navigates creatively through the ever-changing art world. As art dealers and curators, we know that understanding art, artists, collectors, and business requires imagination and ingenuity. This is our art form. Remember that your best relationships in the art community are mutually supportive, and we're all in it together. In the end it's all about integrity and love.

Jean-Pierre Roy, *Artist*

Brooklyn, NY

Half-Time Instructor, New York Academy of Art

One of the most important things for artists to make peace with in their early careers is that there is no inherent relationship between talent and price. The dream is not to be making minimum wage per piece for the rest of your career, but to build a sustainable career that is constantly accelerating over the course of your practice. This can only happen if you begin to get things out the studio door and build relationships by letting go of your work for what can seem, in the beginning anyway, like way too little money.

The accompanying problem is of course that in the beginning you don't really have the money for quality materials, even though it is absolutely necessary to set a level of quality in your early career. Crappy stretcher bars warp. Homemade panels are often inferior to professional grade or custom made surfaces. Student Grade paint is glaringly different than Artist Grade. Making your own surfaces to save money almost always comes at the cost of "time not spent painting" and often leads to a lesser quality product, unless you REALLY do your research about the materials you use.

Creativity and capitalism is weird. You might be emotionally, spiritually, genetically and neurologically driven to make the work, but treat yourself as a small business. Know that you won't be pulling a paycheck out of it for a while and reinvest all your revenue back into the business by buying better quality materials and doing your homework.

Judith Schaechter, *Artist*
Philadelphia, PA
Adjunct Professor, University of the Arts, PA
Visiting Instructor, PA Academy of the Arts and NY Academy of Art

In the end, the only thing that really matters as an artist is loving what you do. I don't mean something like googly-eyed puppy love. I mean the kind of love that endures everything; from invasive input from multiple sources with conflicting agendas to critique so accurate that it threatens to undermine your very raison d'être. I am talking about the kind of love that runs the emotional spectrum from blind obsession and adoration to hatred, to awe. The kind of love that is sustainable in a foxhole, in those deep nights of crushing doubt and when the sirens of distraction lure you away with temptations like love, family, money, popularity, etc. Because in the end, success and attention will not matter if it isn't based on love and if your dreams of success never do come to pass, then at least you will have done what you really, really wanted to do and that is success.

Billy Shire, *Art Dealer*
Los Angeles, CA
Owner/Founder, La Luz de Jesus Gallery

If you go into a career as in artist with the idea of being a hot shit monkey viper grand poobah - don't. The stock market is waiting for you. Art and being an artist is more than a vocation, career, lifestyle. It is a commitment to ideals and creativity, but also to immersing yourself in the muck and grime of the art business. Here are a few thoughts:

Take advantage of school and teachers, learn the basics, above all learn to draw. Learn techniques, tools and materials. Synthesize your abilities and influences and create your own style. Expand and experiment, push your boundaries. It is important to grow and evolve. Be honest to yourself, do not work to the dictates of money and fashion. Create your own trends and style. Don't be a follower, be a pioneer. Of course, if you want to be successful... disregard all my advice.

Tony Shore, *Artist*
Baltimore, Maryland
Faculty, Maryland Institute College of Art

You need to experience life to have meaningful things to make art about. Get out of the studio. Get excited. Get inspired. Have opinions. There are people who are interested in the same things and are waiting to relate to what you have to say.

Don't take yourself too seriously and let your ego keep you from missing out on opportunities to show your work, while waiting to be discovered by your ideal gallery or museum. Take advantage of many group exhibitions and chances to show and get your work seen. You never know who will walk into a space where your work is on the wall. The opportunity to show your work will enable you to meet and share ideas with like-minded people and often lead to lifelong relationships, and a support system for both you and your work. And there is nothing worse than getting stuck with old work stacked in your mother's basement.

Aaron Smith, *Artist*
Los Angeles, CA
Associate Chair, Illustration Dept., Art Center College of Design

Anyone notice how isolating being an artist can be? Teaching at an art college has allowed me to engage with new artists and to give and get ideas about survival in the ever-evolving art and design fields. Here are some thoughts...

Be authentic and your tribe will find you. This is the most pluralistic time in the Art World. There are more artists than ever before, working in more divergent places, producing a bigger variety of kinds of work. Is this a problem? Nope. Wave your crazy-flag high and proud online and everywhere, and your tribe will find you.

Take play very seriously. It is unrealistic to assume that everything you produce will see the light of a gallery wall. Forgive yourself for that spectacular failure. The studio is NOT a factory. It is a laboratory.

Rather than waiting for permission to enter the Art Scene, create one. Who says the Art World has to grant you entry into its embrace before you can participate? Curate yourself and others in any space available. Gather friends and fans from online and throw a party. Document the fantastic event online and repeat. Eventually collectors will begin to nibble, word will spread and galleries may take notice. In the meantime, this practice will allow you to produce new work, gain confidence and eventually demonstrate the value you bring to the Art Establishment.

Finally... Live by the Golden Rule. Be as professional, communicative, and supportive to your gallery, clients and fellow artists as you would like them to be to you.

Mindy Solomon, *Art Dealer*
Miami, FL
Owner/Director, Mindy Solomon Gallery

While many artists receive excellent training in the fundamentals of art - drawing, painting and sculpture as an example - they seem to lack a strategy for how to function creatively and professionally outside of school. One of the greatest liabilities I have seen in the university arts education system is helping students to think of ways to move forward upon graduation. I think it is important for students to be "visible," to construct well designed websites highlighting the strongest examples of their work. They need to be proactive in trying to be seen and exhibited. This could be as simple as creating an Etsy profile online, as well as trying to hang work in alternative spaces - coffee shops, community centers, and restaurants. The goal is to be noticed. Creating artistic cooperatives that can stage pop-ups can be effective as well. Young artists need to be open to selling work for a reasonable price - when you are just starting out your work should be priced modestly - you can always raise it, lowering is much more difficult. Don't throw out the work in your studio - try to sell it - maybe for as little as $10.00, but start thinking about being a business artist. Being out in the visual world is the best way to be "discovered." Network with other creatives, visit design studios, and be accessible.

Sarah Trigg, *Artist*
Brooklyn, NY
Instructor, School of Visual Arts, MFA Fine Art
Author, *STUDIO LIFE: Rituals, Collections, Tools, and Observations on the Artistic Process*

I would pursue being an artist only if it's an identity you absolutely can't shake—that if you don't do it, you get anxious, you get depressed, you're intolerable, etc. That it's something you *need* to do, that you *have to* do—despite parental pressure not to, despite economic concerns, etc. The lives of artists—even of the monetarily successful—are filled with a constant testing of one's insecurities and a lot of rejection. The buoy that will carry you through is your relationship to your work and your true love of making it. Being an artist is not a lifestyle choice.

So, if you know you're one of the wonderfully afflicted, then you must take care of your art making like it's a living being that needs constant nurturing. Otherwise, you will go mad or fall into disease. So, you have to figure it out. And you make the rules. What type of artist do you want to be? What is your position?

Figure out what it is you truly love to do—not what you fantasize yourself being good at, or what your favorite artist would do, but what you are specifically obsessed by. What that turns out to be may surprise you if you are truly honest with yourself. Give yourself the permission to go there even if it goes against conventional "art career" wisdom, and go deep. Because that is where you will find your unique voice in order to contribute to the conversation. Derivative art means work that is parroting something that has already been said. Offer something. Find the thing that only you know like no one else knows because only you are the expert on this very particular obsession.

Hanna von Goeler, *Artist*
Montclair, NJ

It's hard sometimes when things aren't going as planned, but I try to think of every occasion as a learning experience. Preparation is everything. As an installation artist, I spend months in the studio getting ready and anticipating problems, but during installation, it is not unusual for hurdles to arise. I've learned to keep my cool and trust, that in one way or another, it will all work out if I stay focused and persistent, and that this process is making me a better artist. Also, I take every show and project seriously, whether it is a solo show at an established venue, an international show with star artists, or a local show of emerging artists. Since you never know when a killer piece is in the making, there's no point in being an art snob. Resume and networking are only as powerful as the art is. In the end, it's all about making great work and giving people an experience to go home with.

Linda Warren, *Art Dealer*

Chicago, IL

Founder/Owner, Linda Warren Projects

Galleries work with critical and sometimes ever-changing deadlines. From marketing purposes like advertising and creating an invitation or email blast, to requests from clients, curators, collectors or art consultants for information on pricing or imagery, to the making of sales to the delivery and installation of the art - a vibrant gallery is in constant flux and needs artists to be responsive and timely with the gallery's requests of them. Having to call an artist several times for a single piece of information or have an artist be late delivering or shipping an artwork for exhibition, installation or sale is a setback to the gallery's time management abilities, is very frustrating, and of course unprofessional. The gallery is working hard on behalf of several artists simultaneously, and needs to operate like a well-oiled machine. An artist who can't meet deadlines becomes a snag or stall in the process. It eventually becomes not worth all of the effort if both sides aren't working symbiotically to move the ball forward. Success comes with team effort and drive.

Didier William, *Artist*

Brooklyn, NY

There are 3 things that I think are absolutely critical:
- Consistency - keep your brain engaged and your hand active as much as possible. Whether it's small sketches, maquettes, or studies, do your best to continue to make and think about things.
- Balance - feed your output with as much input (books, lectures, films, leisure, rest) as you can handle and in some cases more than you can manage.
- Support - locate the audience who supports your ideas and your trajectory and stick to them like glue.

Mark Wolfe, *Art Dealer*
San Francisco, CA
Owner/Director, Mark Wolfe Contemporary Art

Stay deeply connected and alert to what's going on in your own art world. Under no circumstances isolate yourself in the studio with a solitary practice, thinking you're some kind of lone wolf or Van Gogh. Participate openly and absorb what's going on in the art scene around you without judgment. Give and receive input/support/advice/feedback from other artists freely, generously, and often. If possible, find an artist with more experience than you to serve as a mentor. If asked to mentor someone with less experience than you, say yes. Remember that the history of art has been, is, and will remain one giant, inclusive conversation among dedicated individuals. Finally, develop and maintain a serious, professional work ethic. The old adage is as true for artists as it is for any other creative enterprise: talent without hard work will always lose out to hard work without talent.

Marcia Wood, *Art Dealer*
Atlanta, GA
Owner/Director, Marcia Wood Gallery

If you are working with a gallery and know of other artists who you think would be an excellent fit, by all means make the introduction. It is an important way artists can help each other and the gallerist will appreciate your thinking on their behalf.

Brad Woodfin, *Artist*
Montréal, Québec

Work with people you would want to go out for drinks with. If you have a choice, and maybe at the beginning this is harder, choose people who you relate to, as it is easier to get advice, ask questions, and will make you want to do good work for and with them. One of the great things about being an artist is that you have freedoms that other people don't have, and if one of those freedoms allows you to not work with dicks or people who don't understand you, make the most of that.

Part Eight: *Reminders, Requests & Resources*

Chapter Twenty
Wrapping Up

I feel lucky and grateful to have worked with and to know so many wonderful artists who have enriched my life both personally and professionally. This book was conceived and written from a place of absolute love and appreciation for what you do. I sincerely hope you found it helpful. I'd like to leave you with a few quick reminders and requests and wish you the absolute best of luck and lots of success!

Remember:
- Get in the studio and make work. Keep growing and stretching yourself to make better work. None of the advice in this book is going to do you a bit of good if you don't make time to get in the studio and make work you love and are excited about.
- Cherish your community and cultivate your network. They are your people. They are your lifeline to sanity, perspective, encouragement, and opportunity.
- Always be professional and pleasant. You can build enormous good will and wonderful relationships simply by being on time and easy to work with, now and ongoing.
- Perseverance is key. I've known plenty of artists who have made the decision to put their art career on the back burner and that's

OK. But if you really want it, don't give up or get side tracked. Stick with it.
- To some degree, your art career is going to have a life of its own. Stay focused and keep your goals in mind. But be open to surprise and opportunity. Don't be afraid to revise your attitudes and goals as your journey unfolds. It may not look exactly like what you had anticipated or hoped. It just might be better!

Requests:
- Please do share your experiences with me. If you put any of my suggestions and advice into action and experience results, I'd love to hear about it. And if it's OK with you, and only if it's OK, I'll share your experiences with others. If there's something you think I left out and wish I'd covered, please let me know. I'll try to cover the topic on my blog or even a future update of this book.
- Be part of my network. Explore my website for artists, join the email list and follow the blog, at practicalartists.com. Like the Practical Artists page on Facebook. Invite me to like your artist page. If you found this book helpful, inspiring or effective, share it with your community and network. Write an honest review, even if it's not all positive, wherever you purchased the book or like to post reviews.
- If you run into one of the artists or arts professionals from section seven whose advice you found valuable, thank them for sharing. Each of those people volunteered his or her advice and time for no reason other than to be helpful and supportive. I'm sure they'd appreciate knowing their contribution made an impact.

Chapter Twenty-One
Online Resource List

To follow is a list of general websites and resources. It's current as of the January 2017 update of this book. Because new resources become available and others outdated, I also keep a version of this list, which I update quarterly, in the Resources section of practicalartists.com.

I strongly encourage you to also take the time to do your own research. Look for opportunities in your area. Custom tailor your search parameters to your specific goals, situation and type of work. Also, read articles, posts and ask around. Learning about other people's experiences is not only helpful, it can lead you directly to additional resources and information.

Listings That Include Several Types of Opportunities:
- Art Deadlines List
 www.artdeadlineslist.com - Browse online, receive a free monthly email, or subscribe to a premium list for $12 per year. Lists a wide range of opportunities for artists.
- Art Opportunities Monthly
 www.artopportunitiesmonthly.com - Subscribe to receive a free monthly email or opt for the $30 annual membership. The layout is a bit chaotic, but they do promise to pre-screen all of the

opportunities they list.
- New York Foundation for the Arts
 www.NYFA.org - While a New York based organization, the NYFA website lists many terrific opportunities relevant to those outside of New York.
- re-title Artist Opportunities Section
 http://blog.re-title.com/opportunities/ - Their artist opportunities page includes many interesting listings.

Call for Entries
- The Art Guide
 http://theartguide.com/calls-for-artists - Doesn't offer a search option but the list is easy to scroll through and find information.
- Artshow
 www.artshow.com/juriedshows/index.html - Call for entries are listed by region. Also includes an international list and contests/grants section.
- Call For
 www.callfor.org - Open calls in a variety of categories.

Grants:
- Cranbrook Academy of Art Library
 www.cranbrookart.edu/library/research/grants.htm - This is a great list that includes grants by region.
- Arts & Healing Network
 www.artheals.org/artist-support/art_grants.html - A terrific site dedicated to healing through art. You might enjoy exploring not just the grants page, but the entire site.
- Art Business

www.artbusiness.com/osorgrants.html - This link is to an excellent article about grants. The Articles for Artists section of this site has useful articles on a variety of topics.

Residencies:
- Alliance of Artist Communities
 www.artistcommunities.org - Don't be scared off by all of the language about membership and joining. You can create a free user account to search the residency directory and receive a monthly email.
- ResArtis
 www.resartis.org/en/residencies/list_of_residencies/ - This site has a terrific search function allowing you to narrow down residencies by location, duration and other parameters.
- TransArtists
 www.transartists.org - Offers tons of information and advice about residencies all over the world.

Jobs:
In addition to finding job listings on sites like NYFA and searching for arts-related and creative jobs on general sites like Indeed, Monster and Craigslist, you can also try these:
- Art Jobs
 www.artjobs.com/art-jobs - Narrow your search down with the options on the right.
- Art Search
 http://artjobs.artsearch.us - Lists gallery, education and art jobs.

About the Author

In my first "grown up" job, at the La Luz de Jesus Gallery in Los Angeles, I was fortunate to begin my arts education under the mentorship of the legendary Billy Shire, and to work with several artists who have gone on to achieve critical and financial success. I took a break from the art world and worked in television and film production and as an advertising copywriter for a few years. Then in 2001, I returned to fine art full time as a private dealer, consultant and curator. I moved to New York in 2005 and opened Sloan Fine Art, a contemporary gallery specializing in emerging to mid-career artists, on the Lower East Side in January 2008. Over the next four years, the gallery presented dozens of solo and group exhibitions highlighting hundreds of artists. It was a magical time but New York rents and evolving priorities prompted me to close the brick-and-mortar space at the end of 2011. Since then, I've been mounting pop-up exhibitions and participating in art fairs under the Sloan Fine Art banner, and consulting for clients on a wide range of projects. I also co-wrote a mystery thriller called *Pet Sitter: A Jenna Stack Mystery* by Amy Eyrie and Alix Sloan. If you like that sort of thing, check it out. Amy and I are finishing up two more Jenna Stack mysteries now.

After several years offering one-on-one artist consultations and lecturing at art schools across the country, I decided to write *Launching Your Art Career: A Practical Guide for Artists*, with the goal of making straightforward, practical advice available to artists everywhere. You can access additional information for artists, free worksheets, lists and information, learn more about the services I offer, and sign up for email updates, at practicalartists.com.

Acknowledgements

I am fortunate and grateful to have such a supportive, creative family and so many wonderful friends and colleagues, all of whom encouraged me to organize my thoughts and put my desire to help artists to paper. In particular...

To all of the amazing artists and arts professionals who shared your experience and wisdom in section seven - thank you! Drew Fitzpatrick, thank you not only for your thorough and insightful feedback and editing on this project, but also your endless support, encouragement and good-natured attitude towards every project, and every day. Editor, friend, frustration wrangler and head cheerleader Amy Eyrie, what can I say? You are the best! Shane Eichacker for your wonderful cover design, stoic patience and endless encouragement, thank you. Early readers Julia Marchand, Jessicka Addams and Jaymay, thank you so much for your time and valuable feedback. Suzanne Keilly, from the first moment of inspiration to the last day of proofreading, thank you from the bottom of my heart. Linnea Knollmueller and Geof Smith, thank you so much for your friendship, expertise and input.

Special mention and thanks for various invaluable bits of insight, encouragement, feedback and good vibes throughout the process go to Kirsten Anderson, Noah Antieau, Carrie Ann Baade, Rebecca Borden, Joe Bel Bruno, Peter Drake, Janice Faber, Anna McClelland, Martha Rich, Jean-Pierre Roy, Aaron Smith, Heather Stewart, and my wonderful parents Alan & Sally Sloan. And to my Stanton Street family - Jennie Willink, Wendy Weston, Ruby Weston, Steven Matrick, Jenn Krakowski and Colleen Adams Goujjane - I love you guys!